Destination Creativity

The Life-Altering Journey of the Art Retreat

Ricë Freeman-Zachery

NORTH LIGHT BOOKS
Cincinnati, Ohio

www.createmixedmedia.com

Distributed in Canada by Fraser Direct
100 Armstrong Avenue
Georgetown, ON, Canada L7G 5S4
Tel: (905) 877-4411

Distributed in the U.K. and Europe by
F&W Media International
Brunel House, Newton Abbot, Devon,
TQ12 4PU, England
Tel: (+44) 1626 323200, Fax: (+44) 1626 323319
E-mail: enquiries@fwmedia.com

Distributed in Australia by Capricorn Link
P.O. Box 704, S. Windsor, NSW 2756
Australia
Tel: (02) 4577-3555

www.fwmedia.com

Ricë, Tonia, and The Ever-Gorgeous Earl, Milwaukee, Wisconsin

Editor: Tonia Davenport

Designer: Geoff Raker

Production Coordinator: Greg Nock

Photographers: Earl Zachery and Ric Deliantoni

Dedication

To Earl:

I really, truly could not have done this one without you.

Acknowledgments

Writers always say they couldn't have completed their books without help. It's absolutely true. Without the artists and retreat organizers and contributors, and without my editor, Tonia, and my photographer/husband/driver/voice of sanity, Earl, I wouldn't have even dreamed of doing this book.

Thanks go first to my five artists, Daniel Essig, Melissa Manley, Deryn Mentock, Jesse Reno, and Carla Sonheim. Without the generosity of mixed-media artists sharing what they've learned through years of developing their skills, there wouldn't be a mixed-media community at all. These are the best, and working with them is a joy.

Our adventure was made possible by the fabulous retreat organizers: Jeri Aaron, Glenny Densem-Moir, Katherine Engen, Teesha Moore, and Linda Young. They're the ones who dreamed these retreats into being. For this project, they granted us complete access to their retreats, providing rooms and meals and encouragement, and their generosity made a financially daunting project a reality. Thanks to Marlene Vail of Bead&Button and Rhianna White of Quilts, Inc., also, for their kind assistance.

Special thanks to the teachers and students who allowed us to come into their workshops and ask nosy questions and take photos and video and try out tools

and supplies and oh, my—just be a part of the excitement. We had a blast with y'all, and we thank you so very much for your hospitality.

My wonderful editor, Tonia Davenport, was an integral part of this book from start to finish. Decades ago, Earl and I talked about how much fun it would be to someday collaborate on a book—I'd do the words; he'd take the photographs. Tonia made that dream come true for us when she suggested this project, and we're both so very grateful. It was icing on the cake that we got to hang out with her in Milwaukee and Phoenix, never mind the little difficulties we had actually—ahem—finding the restaurants she remembered. She's worth nearly starving to death any day!

And, as always, there's Earl. He has been hugely supportive of every project, but this one depended on him completely. Not only did he take the photographs that bring the retreats to life, but he drove every mile of the way, scouted out classes for me, remembered people's names, fed me, and made sure I didn't run screaming into the wilderness when we checked into some of the less savory motels along the way.

I'm incredibly lucky to get to do what I do, and I thank you, dear reader, for being a part of the adventure. My hope is that you find inspiration between these covers.

Home

Contents

Introduction

Most of the mixed-media artists I've known talk at some point about how it felt before they found "their people." For most of us, there's a vague sense of not fitting in, of being interested in ideas and materials that completely baffle our friends and families and co-workers. It's an odd feeling to be so out of step with almost everyone we know. What if, then, there were a community out there—one in which everyone were like you. Not "like you" in the sense that they're scary clones, no. "Like you" in the sense that these are people who love nothing better than holing up in a room making something out of paper or metal or glass—something that may or may not work out and that they may or may not ever even show anyone—but something they feel compelled to make. These are people who maybe don't care about clothes or cars or sports teams but can—and do—wax poetic about, well, wax. Acrylics. Paverpol. Rusty bits of iron.

It turns out that there is, in fact, just such a community. It's not a static one in a specific geographic area, with a mayor and a city council and garbage collectors. Nope. What it is is a community of mixed-media artists—those who are just starting out and those making a living at it and all those who fall somewhere in between. It is a virtual and often far-flung community that, every now and then, comes together at a retreat. The more I heard people talk about how one of these art retreats had changed their life, the more certain I was that I needed to 1) find out more and 2) see if art retreats really are all that, and then spread the word.

So in January 2010, I hired my husband, The Ever-Gorgeous Earl, as my photographer and set out on a year-long journey to study art retreats. I bought the maps and did rather a lot of planning, and then we hit the road. Ten months and many thousands of miles later, I have my answer: art retreats do change lives. Sometimes the changes are small, and sometimes they're huge. One woman told me the poignant story of how she registered for an art retreat intending it to be the last chapter of her life. Being there, though, surrounded by people who understood her and valued the same things she did, she realized that she wasn't ready to end it after all and that there was a huge, wide world she'd only begun to discover. Art literally saved her life, and that art retreat was the lifeline.

Most of the stories I heard weren't so huge; most were stories of small changes, of attendees finding "their people," or of finally getting validation that the things they love—metal and paper and fabric—are, indeed, worthwhile; never mind what their friends and family think.

Since I realized it's not possible for everyone to attend one of the large, well-known retreats, I also wanted to encourage people to find ways to bring the art retreat experience home, whether it's to your own studio or to something slightly larger. Because the chance to get together and make art with other people can be so inspirational, I people to be able to experience it in whatever way is available to them, whether it's in their studio or a church basement or a hotel in a nearby city. It's worth it—it really is.

When I thought about whom to ask about art retreats, my first thought was Dale Wigley. Dale is the Grande Dame of art retreats; at age eighty, she has more energy and stamina than most people half her age, and she attends more retreats in one year than most people do in a lifetime. So I asked her, "What's so special about art retreats, anyway?" Dale says, "Attending art retreats is my favorite thing in the world to do. You get to travel, you get educated about many different mediums, you meet wonderfully talented attendees as well as instructors, and it makes me smile and be happy. Isn't that what life should be about? I attend about five of these a year; aren't I the lucky one to have, at age eighty, free time to go and create with some wonderful artists? I have made so many lifelong friends now who 'understand' me and what makes me tick, while my old friends at home say, 'Where in the world is she going now, and what in the world is she gonna come back with?'

"If you have never been to an art retreat, I urge you to attend one. You'll not only learn a lot (particularly if you do like I do and take things that really aren't your field just to see what is out there and floats other people's boat), but you will never find a more friendly bunch of folk in your life who will laugh with you, cry with you, and understand what you are about."

That pretty much says it all. While I've tried to put into this book everything I think you could possibly want to know about art retreats, there are things I've missed, I'm sure. You're going to have questions about specific classes and instructors, and that's OK:

The online groups and Web sites will tell you everything you need to know. Go there, ask questions.

In the meantime, you can have your own virtual retreat right here. I picked five of the most exciting instructors teaching today and asked them to participate. We went to their classes, and they generously provided detailed step-by-step instructions. You can make metal jewelry with Melissa Manley and Deryn Mentock, you can draw with Carla Sonheim and paint with Jesse Reno, and you can make a centipede binding with Daniel Essig. As Dale says, there's nothing like trying something new to find out what's out there. Whether you host your own mini-retreat in your home studio or start planning right now for one of the biggies, art retreats really can change your life.

Meet the Instructors

Daniel Essig was born in St. Louis, Missouri, and studied at Southern Illinois University, Penland School, and the University of Iowa. Ten years ago he moved to Asheville, North Carolina, where he has maintained a full-time studio at Grovewood Gallery. Daniel Essig lectures and offers workshops at book centers, craft schools, colleges, and artist retreats, as well as privately. Dan has created wooden and sculptural books for more than twenty years. He is a recipient of the North Carolina Artist Fellowship Grant. Daniel exhibits his work nationally and is in numerous private and public collections. Recently his work has been collected by the Smithsonian Renwick Museum, the University of Iowa Libraries, and the Topeka library. Many of Daniel's sculptural pieces are featured in *The Penland Book of Handmade Books*.

www.danielessig.com
www.grovewood.com/grovewood-studios
www.penland.org/gallery/gallery.html

Melissa Manley lives and works a few miles from Wrightsville Beach in North Carolina. She received her BA in studio arts from the University of North Carolina at Wilmington. In 2006 she earned her MFA in Metal Design at East Carolina University. Melissa now teaches metals at Cape Fear Community College in Wilmington in addition to teaching workshops around the country in collage, book altering, watercolor and jewelry making. Her work has appeared in *Somerset Studio*, *Belle Armoire Jewelry*, *Crafting Personal Shrines* by Carol Owen, *The Art of Enameling* by Linda Darty, *Making Connections* by Susan Lenart Kazmer, *500 Enameled Objects* by Lark Books, and *Collage Lab* by Bee Shay. Melissa winds down from the dizzying pace of making a living with her art by kayaking and beachcombing with her partner, kayak instructor Robert Smith, and her teenage daughter, Meredith.

www.melissamanleystudios.blogspot.com
www.melissamanleystudios.com

Deryn Mentock's designs gather unique, worn, and well-loved finds; vintage religious pieces; and faceted, semiprecious stones, as well as her one-of-a-kind handmade elements, combining them in unexpected ways. Each composition, infused with color and texture, reveals an intuitive message of faith conveyed through the artist's hands. She travels nationally and is passionate about offering her students instruction in not only technique, but also design and the creative process. Her work has been featured in numerous books and publications, including *Somerset Studio*, *Step by Step Wire Jewelry*, *Belle Armoire Jewelry*, *Handcrafted Jewelry*, and many more.

mocknet@sbcglobal.net
www.somethingsublime.typepad.com
www.mocknet.etsy.com

Jesse Reno is a self-taught mixed-media painter who lives and works in his home studio in Portland, Oregon. Jesse has been drawing since he was five years old and painting and showing his works publicly since 2000. Using a DIY approach and hard work, Jesse has amassed a portfolio of hundreds of paintings, and his work can be found in fine-art galleries, on city walls and skate decks, and in books, magazines, and private collections around the world. Jesse's paintings tell timeless stories using figurative images and symbols in a suggestive format that people can apply to themselves. His biggest inspirations are the art of primitive, indigenous, and shamanic painters.

www.jessereno.com

Carla Sonheim is a painter, illustrator, and creativity workshop instructor known for her fun and innovative projects and techniques designed to help adult students recover a more spontaneous, playful approach to creating. She is the author of *Drawing Lab for Mixed Media Artists*, and creator of "The Art of Silliness," a popular online drawing course consisting of activity sheets for adults. Carla lives in Seattle, Washington.

www.carlasonheim.com
www.artofsilliness.com

9

Creating on the Strip
Art & Soul, Las Vegas

WHERE: Bally's and Paris Hotels, Las Vegas, Nevada

WHEN: Mid to late February (Wednesday–Sunday)

WHO RUNS IT: Glenny Densem-Moir

COST: Classes are priced individually, and rates vary ($100 and up). Lodging and meals are not included, but attendees get a special rate if they stay in rooms reserved for the event.

SIZE: 250+ attendees, 36+ classes, 14 instructors

Art & Soul, Las Vegas, is a brand-new-this-year addition to the popular group of Art & Soul retreats designed by veteran retreat organizer Glenny Densem-Moir. She's been hosting Art & Soul retreats around the country—Portland, Virginia, Dallas, Asilomar—since 2002, but this is the first year in Las Vegas, where approximately 250 people—70 percent of them *newbies* (brand-new attendees)—converge on Bally's and Paris—adjoining high-rise hotels on the Strip—for five days of classes, shopping, sharing, inspiration, and maybe just a tiny bit of sight-seeing.

Saturday, February 20

Finally, Las Vegas! Our drive here took a couple of days, with stops for book signings for my *Creative Time and Space* at a Barnes & Noble in El Paso, Texas, and Frenzy Stamper in Scottsdale, Arizona. Debbie Bick, the owner of Frenzy Stamper, is a wonderful hostess, and we had a great time hanging out and visiting—plus it was a nice little stop on the long drive through New Mexico and Arizona. And now that we're finally here, all I can say is, "Holy moly! Las Vegas is one busy place!"

It's been a whole bunch of years since we've been to Vegas, and of course the main differences are: More people. More traffic. More buildings! I get us to the Strip and to Bally's, which is connected to Paris, which is the other half of the venue. As you would expect in Vegas, they're big. Very, very big. I love Paris

immediately—what a cool building. In fact, most of the hotel exteriors are so ornate you could spend hours just walking around with your head tilted back, staring at the architecture.

Our room is on the sixteenth floor of one of the towers, and the first thing we notice on our way to the elevators is the cigarette smoke. Lots and lots of smoke. Duh—the lobby of the hotel is Bally's Casino, and that's what people do in casinos: smoke. I kind of wonder if maybe they're not even there to gamble; they just like being able to sit and smoke in public.

I love our room. I love the gigantic window, where I can sit in the sun in the morning and look out at the mountains in the distance while I drink coffee. Gorgeous.

There's a lot of walking involved here. The rooms in Bally's are in one tower, and you take the elevator down to the lobby level, walk through the lobby casino, and take either the elevator or the escalators up in the other tower, where most of the workshops are held. Not all, though; some are held on the first floor behind the casino, so you may have to trek a bit. Fortunately for me, I love to walk.

Note

Since most retreats have classrooms spread out over the available area, you're probably not going to want to carry all of the supplies you brought to each and every class. Veteran retreat-goers typically bring some sort of rolling case—either a suitcase or a container designed for scrapbookers or stitchers. Check your local arts and crafts suppliers to see what they have or check online for rolling cases. Having one will make your life SO much easier.

Note

If you have mobility issues, larger hotels often can accommodate you with electric scooters. Glenny usually uses one, and attendees often rely on these to make getting around comfortable, rather than challenging. You can call the host hotel before you register to make sure they can help you.

11

After Hours

Many of the retreats don't have a lot of activities scheduled after hours. Classes here run from 10AM to 5:30PM each day, with a nice long lunch break from 12:30 to 2PM. Sometimes there's an evening workshop, but generally people are on their own. This is great if you want to see the sights or if you've made reservations for a show, but it can be a little lonely if you've come on your own and haven't made any plans.

Fortunately, it's easy to hook up with people ahead of time via the online Yahoo groups for each retreat. If you're traveling alone to one of the retreats, check the schedule ahead of time to find out what's going to be offered in the evenings. If you're not crazy about spending the evenings in the hotel bar or in your room alone, look online for a list of local activities. In Las Vegas, lots of people had made reservations to see Cirque du Soleil—that's the kind of thing you'd want to plan for in advance. There's a lot to do and see in almost any host town, but it's kind of overwhelming to try to arrange things after you arrive. While you will want to schedule in some down time, you don't want to get back home and regret all the things you could have seen if only you'd known about them.

Themes

Most retreats have a different theme each year, from Alice in Wonderland to Marie Antoinette to, well, almost anything. Although no one is forced to embrace the theme, it can provide lots of ideas for name tags, swaps, artist trading cards, costumes—you name it.

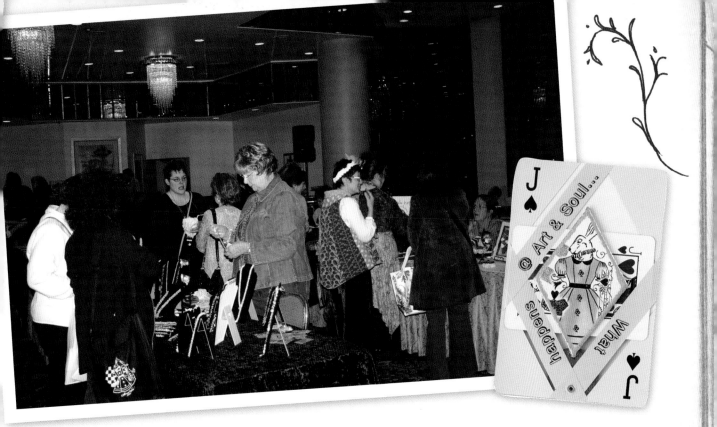

Tonight is Vendors' Night, where selected artists set up tables and sell their work. I love Vendors' Night; it's a great chance to see new work by all of my favorite artists. You're buying art you get to see up close, you're supporting working artists, and there's no middleman taking a chunk of the profits. Vendors' Night is the best! I talk to Stephanie Lee, who's pleased with the article we did that's just come out in *Belle Armoire Jewelry*, and Richard Salley, who's working with me on an article about his work. I meet Robert Dancik, who's doing really cool stuff with Faux Bone. I'm thrilled to see Dale Wigley and her new work. She's making fabulous silver chains, and she looks great.

After the excitement of Vendors' Night, we eat a delicious late dinner at Le Provencal—escargot and scampi and wine and dessert—and then we walk around for a long time, trying to burn some of it off. Bally's and Paris are great for walking and wandering through the maze of shops and restaurants that connect the hotels. You descend into a world of cleverly faux French streets with a painted blue sky and stars that come out at night, and it's as if you've really been whisked away to France. Well, OK, I've never been to Paris, so I'm easily led into fantasy.

Vendors' Night Suggestions

While some artists sell their work regularly and are set up to accept debit and credit cards, many are not. They may sell only once or twice a year, making the credit card fees unreasonable for them. Almost all vendors will accept checks, but cash is always appreciated, so make sure you bring some! Don't haggle. This isn't a flea market; these artists have chosen work they hope you will like and want to take home, and trying to talk them down to a price lower than the one they think is fair is insulting. While some artists will adjust the price when someone buys more than one piece of their work, it's rude to ask them to do this. If they have something you love but can't afford, compliment them on the piece and ask for a card so you can check out their work online.

And if you're vending? Think carefully about pricing. You want to price things so you'll make money, but you want to make sure that people can afford to buy your work. It's a really good idea to have a range of price points. If your work tends to be expensive, think about offering prints or postcards or maybe pins—something that's more affordable for someone unfamiliar with what you do. Someone who buys a pin this time around may save up to buy a larger piece next time.

Back in the Studio

If you have a local group of artist friends, think about setting up your own Vendors' Night in someone's studio. Everyone can bring pieces they'd like to sell, and you can send out invitations to the people on each artist's mailing list. Provide snacks, wine, beer, and music, and you've got an Evening of Art. Even if the sales aren't great, it's a wonderful opportunity to see other people's work and share ideas.

Sunday, February 21

Classes start today. We've signed up for only one class—on Tuesday—so we can visit as many of the other classes as possible, checking out the projects and enjoying the energy. I love my job! Earl heads out early to see what's going on in the classrooms, and I go up to The Store to check in with Glenny.

Today's selection of workshop choices includes metal etching with Sherri Haab, a class on soldering with Sally Jean Alexander, a journal workshop with Jan Harris, and a number of other choices. There really is something for almost everyone, no matter what your interests.

The Store

At the first Art & Soul retreat in Portland, Glenny used to run shuttles to Collage, an art supply store in Seattle run by Maria Raleigh. In 2008, Glenny and Maria decided it would be great for everyone to have the store on-site so if someone checked into their workshop and then suddenly realized they'd forgotten to pack their canvas—or their watercolors or clay or beads or whatever—they could just run to the store and get it.

Maria works with the instructors' supply lists to offer as many of the required supplies as possible. While she can't carry every single thing, she stocks an amazing amount of it, and people rush in and out all day long, picking up things they've forgotten or run out of or just suddenly decided it would be fun to try.

Deciding Which Workshops to Take

The choices can be overwhelming, indeed. Do you go with someone famous you've heard good things about, or do you try some technique that you've always wanted to learn? Do you take a new class offered by someone you've taken from before, or do you go with the new instructors, trying out something fresh and unexplored?

The best advice? First, pick your I-have-to-have-this-one workshop—whatever it is. Then pick something new that grabs you. Third, if these first two are really intense, physical workshops—soldering or sawing, for example—you might want to make your third choice something more meditative, like a journal class.

Some people fill every day with as many workshops as they can, figuring they can rest when they get home. Others know that they've got to schedule in some down time. Only you know what you and your body need, so take that into consideration when you design your schedule. Keep in mind that your first choices may be filled, so pick secondary choices that intrigue you, just in case.

Dale Wigley comes into The Store, and we all tease her about being an Art Retreat Junkie—she's just turned eighty this year and is planning a train trip through Canada with two of her kids, but she's having trouble figuring out how to work it in among the art retreats; she seldom misses any of them.

At lunchtime Earl and I go back down to the restaurants and have a delicious brunch of wine, cheese, fruit, and bread, which fills us up and means we don't have to find a place to eat dinner. After the workshops are over for the day, we spend the evening walking—I love this about Las Vegas. There are so many shops connected to the hotels that you can walk for miles even on damp, chilly evenings, not having to venture out into the dark.

Monday, February 22

We first met Ty and Marcia Shultz at Art Fiber Fest in Seattle. In their former life, they made props for Canadian film and television, so if you've watched, say, *DaVinci's Inquest*, where they dig up parts of an old body, you might have seen Ty and Marcia's work. They've taken the skills and techniques from that former life and adapted them into innovative and exciting workshops.

If you're not really interested in collage or journaling or jewelry making, you might be intrigued by Monday's class, "Anthropomorphic Critters," where students make really funky creatures out of strips of old T-shirts and this cool, glue-like stuff called Paverpol. I really wish I'd signed up for this class, so I'm in and out all day long, and every time I come back in, the creatures have evolved a little more.

We meet Michael McMillen, a former video game creator whose wife dragged him to Art Unraveled a couple years ago. Now he's a complete convert to art retreats, explaining, "I left that first conference totally and completely exhausted and with more ideas swimming around in my head than I knew what to do with."

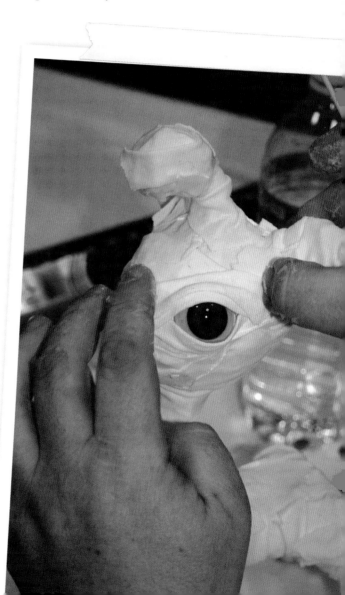

Michael McMillen's Story

Michael burned out on creating video games when he realized that he was working with a bunch of ones and zeros and wasn't creating any tangible art at all. His wife, Erin, badgered him into going to Art Unraveled with her. He grudgingly signed up for a bunch of workshops, and, he says, his life changed forever.

"I was introduced to a world I had never known about. Here I was standing in the doorway to a world of tangible artwork—the idea that I could do things that were uniquely me with the skills that I learned. . . . I learned that the classes are not just craft, but many are true art classes, classes that require you to go home and practice. I took classes from Susan Lenart Kazmer, Richard Salley, Michael deMeng, Louise Duhamel, and Leighanna Light, just to name a few. I have always been a tool guy. My grandfather and I used to build stuff—crazy stuff. I walked into Richard's class, and he pulled out a hammer and some pliers, and I was back home.

"I think that most men look at this stuff and think, 'Why do I want to make a necklace?' and don't think past that first knee-jerk reaction to the fact you get to hammer metal and bend it, cut it, smell it burn and cool. You get to feel it in your hand and shape it into something that's yours. You get to break toys and dis-a-re-assemble them into insane creations in deMeng's classes. Take clay and sculpt it into whatever your mind can think of, and when you're done, it's a silver pendant you can wear. You don't want the cherub with cute little wings? Fine. Make a skull with wings. That's what I love about this stuff: None of the instructors has ever told me that I have to make the project just like they did. In every case they celebrate with me the fact that I am doing my own thing with what they are teaching. I could go on about this stuff for a very long time."

I love Michael's enthusiasm and think he should be made Art Retreat Ambassador.

17

After class, we hit Le Buffet. Surely you've heard of the legendary all-you-can-eat buffets of Las Vegas? These things are humongous. The lines are really, really long, but the people are friendly, and even picky eaters like us have a ton of stuff to try. We try to sample as much as possible, but it's tough. Even with just one bite of each, there's no way you'd have room for every single dish. Man, this is a *lot* of food. We make a valiant effort in the name of research, though.

And after dinner? After the buffet, you *have* to stroll the Streets of Paris for a long, long time.

Tuesday, February 23

Today we're students! When we asked Carla Sonheim if we could photograph her Las Vegas Drawing Extravaganza, she generously said, "Sure!" and then added the caveat that, first, we had to be students. For the morning half of the class, we had to sit at a table, use the supplies, and do the exercises. *Yiiii!* It's one thing to be a reporter and tell people about what it's like to take a workshop, but it's another thing entirely to take the workshops yourself, you know?

I love Carla's work. And so, of course, I would love to learn to draw like Carla: freely, imaginatively, intuitively. She assures me that this is possible—never mind that I tense up at the very word "draw" and have never been able to get past my inborn perfectionism. The combination of not being able to draw and insisting, in your head, that everything—every. Single. Line.—be perfect? Bad combination.

The room is nice and large, but the lighting is not so great. While the sparkly chandeliers are lovely to look at, they're way up high and cast a pallid yellow glow, rather than a nice clear light you'd prefer to have for drawing. Or for doing any kind of art. We hear people complaining about the lighting in all the classrooms.

Note

Because the lighting at retreats—whether they're held in hotels or forts or someone's home studio—can be really iffy, you may want to bring your own task lighting. Many retreat-goers have portable OttLites in their tool kit. Because power outlets are sometimes scarce, you might want to look into a rechargeable, battery-powered light.

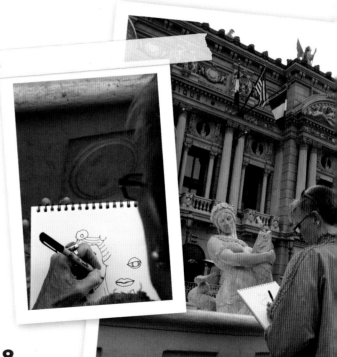

18

Carla introduces herself, and we go around the room with brief introductions, telling why we want to take a drawing class and what we hope to learn. Several people are artists who have been drawing and painting for decades. Penny has taken Carla's class before at Artfest and is thrilled to have the opportunity to get to do it again. Debbie is a middle school art teacher who tells us that, after years of teaching art to kids, "I'm doing this for *me*." Carla is surprised—and pleased—to have two husband-and-wife couples in her class: it's the first time she's ever had more than one man in a single workshop.

One of my favorite things about Carla's teaching style is that she uses analogies, so the act of drawing makes sense even to those of us who have never drawn. She likens the practice of drawing to the practice of tennis: you don't just pick up the pencil or the tennis racket and expect to be an expert with it. It takes practice. When she demonstrates her layering technique, she cautions against jumping in with too many colors all at once, reminding those in the workshop who love to cook that, when you first begin to cook, you don't pull out every spice in the cabinet. You start out, she reminds us, with a little garlic salt, maybe a little basil. When you begin to add color to your drawing, you pick just a few colors.

"My husband Steve and I are taking salsa dance lessons," she says. She explains that they're not natural dancers and that this class is really a challenge for them. Watching the instructor demonstrate the moves, they're sure they'll never, ever be able to duplicate them with that degree of grace and fluidity. But every once in a while they'll execute a turn so smooth and so coordinated that it elicits a little yelp of joy: they can dance! This is what drawing is like: you look at the drawings of someone who's been drawing for

years, and you think, "Oh, I'll never be able to do that." But as you practice and work at it and make mistakes and work over those rough patches, you begin to make little individual drawings that you actually like, ones that make you give a little internal yelp.

Carla is self-taught—her first degree was in history, and her various pre-drawing careers were in law, graphic design, and illustration. When she began to make her own art, she had to learn how to work past those first fears of "Omigod, I'm doing it the wrong way!" and then that certainty that you've screwed it up so thoroughly you might as well ditch it and start over. So she knows all about those fears and the importance of working through them. She's gentle, and she's encouraging.

By the time she leads us into the final drawing project, we feel more relaxed and comfortable with the concept of drawing.

Las Vegas Drawing Extravaganza with Carla Sonheim

"My idea for this class was to take advantage of our time in Las Vegas," Carla explains. "I decided to morph it more into our particular experience, which includes finding creatures in strange paint blots and walking around drawing parts of buildings." And lions—there are lions and lion heads all over Las Vegas, for some reason, and it turns out these are perfect images for creating really cool drawings.

Carla starts us off by having us do various warm-up exercises—nondominant-hand drawings and blind contour drawings and really messy drawings using sticks of charcoal.

Class Supply List

scrap paper, 6-12 sheets

pencil and eraser

ink

Ultra-Fine Point Sharpie, black

charcoal

photographic reference (Carla took her class on a walk-about on the Strip, where we collected images. Take your camera on a jaunt around your neighborhood for lots of potential images like the one Carla uses here.)

5" × 7" (13cm ×18cm) hot-press watercolor paper

markers in both light and dark shades (Carla likes Copic markers, but others will work.)

fine-point markers in a variety of colors

colored pencils

white paint pen

Micron 01 pen, black

Warm Up!

Exercise 1: Wrong-Handed Portraits
Take a piece of scrap paper and either sit across from another person or face a mirror. You can look at the drawing, and you can lift up your pencil on this one, but you have to use your nondominant hand to draw the portrait. Try to think of it as play, rather than a struggle.

Exercise 2: Ink Blotches
Fold a sheet of paper in half. Open it up and dribble some ink in the middle, and then refold it and press to make the ink spread. Open and let dry. Study the ink blot to find hidden faces or creatures or plants, and use your Sharpie to refine the details. Add eyes, leaves—whatever small, simple details you need to make your blot come alive.

Exercise 3: Blind Contour Drawings
Find a model—a stuffed animal or a lamp or chair. Without looking at your piece of scrap paper, trace the contour of the object: put your pencil on the paper, and as your eyes go slowly around the shape of the actual object, let your pencil echo that journey on the paper. Take your time and go very, very slowly so you don't miss anything. Don't look until you're finished!

Exercise 4: Charcoal Drawings
Use a rough piece of charcoal to draw the same object. This time you can look at the paper, and you can lift the charcoal as needed. The object of this exercise

is to experience the lack of control over fine details demanded by the stick of charcoal so that you're forced to loosen up. Use the edges and sides for shading and mark-making.

I loosen up and enjoy myself—never mind that when Carla goes around the room and talks, ever-so-gently, about each person's little pile of exercises, I can't tell exactly which of the props I was trying to draw. Is that my frog? Or was it the bird? Somehow it doesn't matter: in Carla's hands, it's not whether you make the drawing look like a photo-realistic copy of the object you were drawing, but whether you let yourself make marks that you can then make into *something*, whether or not that something has any relationship to what it started out as or not. This is fun!

After we're done with the warm-up exercises, it's time for lunch, so we head out to the Strip.

After lunch we settle into work mode. Carla gives Earl and me permission to sit in on the rest of the class without actually participating. Whew. Earl takes photos of the exercises I did in the morning. I set up the laptop so I can take notes while Carla talks and does demos. Suddenly I start to feel better. My neck stops aching. My shoulders relax. I begin to feel normal again. I heave a huge sigh, and with that sigh, I realize exactly how it feels for the people who come to retreats and take workshops in mediums that are completely unfamiliar to them: It's scary, and it makes you tense, and you're out of your element and afraid of making a big mess and totally wasting your time and looking stupid when everybody else is having a fantastic time and making marvelous art. The idea that you might not be doing it "the right way," or that you might be making a mistake is terrifying. Carla, however, knows all about this and is very reassuring.

While Earl and I are working, Carla begins her exercise with the class on drawing a lion. Follow along with Carla and the rest of the class here, and see how your own lion comes out.

Note

If you're a little nervous about taking a class in something completely unfamiliar to you, don't hesitate to ask veteran retreat attendees to suggest instructors whose teaching style will work best for you. If you know you need someone to push you and make you work, you might want to choose a different teacher than you would if you need someone gentle and nurturing. Ask; attendees are thrilled to offer suggestions and tell of their own experiences.

1 Find a photographic reference of a lion statue, either online or in your neighborhood. (This lion was just blocks from Carla's house in Seattle, near the train station.)

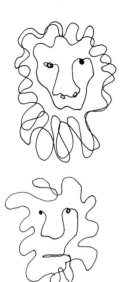
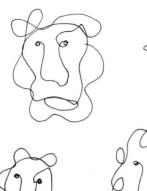
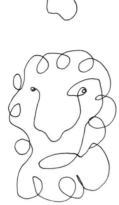

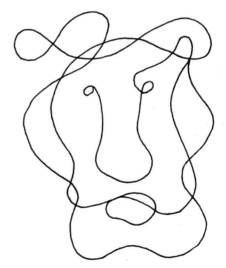

3 Pick your favorite and redraw with pencil on a sheet of hot-press watercolor paper. Your eraser might come in handy at this point.

2 Looking at your photo reference, do 6–12 one-line drawings of the lion's face on scrap pieces of paper. Here's how: Pick a place to start (an eye, the top of the head, etc.) and put your pen to paper. Now draw the lion's face *without* lifting your pen. Think loops, and try to work fairly quickly and without thinking too much, just letting your hand flow over the paper. Refer to your reference often. Carla says, "Don't fret if some of your attempts are 'ugly.' Since you are working from instinct and impulse, this process will likely produce some strange drawings!"

4 Trace your pencil drawing with a black Ultra-Fine Point Sharpie (or other thin permanent marker). Erase any pencil lines that are showing.

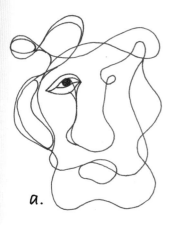

a.

b.

c.

d.

6 Look at your lion before going to the next step. Do you like it? Does it *look* like a lion? Carla says, "In this case, I thought it looked a little like Santa Claus, so I added some other lines to the mane to make it look more like a lion, then I repeated Step 5."

5 Now play with those lines! Carla says, "Your goal is to add weight and form; make lines thicker here and thinner there, round corners, etc. Add eyes and other details if you like." Fill in with black marker.

7 You now have a finished black-and-white drawing and are ready to color.

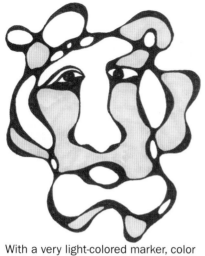

8 With a very light-colored marker, color in some of the shapes. Carla uses light brown here.

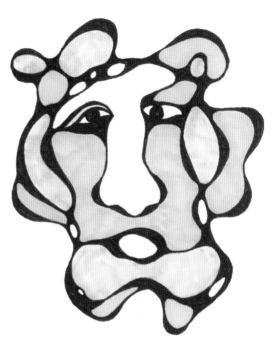

9 With a second very light-colored marker, fill in some more shapes—here she uses light pink. She says, "Leave some areas white!"

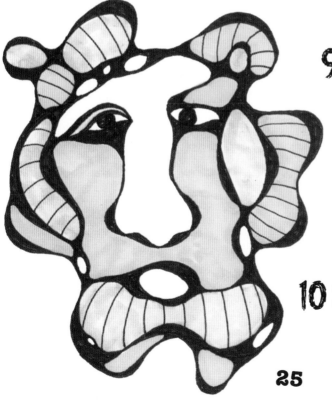

10 Add some decorative lines with a thin-tipped colored permanent marker—she uses magenta.

11 Apply a light layer of colored pencil over all colored areas. Carla uses brown. At this point, she says, "The change will be subtle."

12 Apply a second color, this time adding color under the eyes and around the edges in a shading fashion—here she uses a red-pink.

13 You might want to add a third color. Carla says, "Here I added some green, but I allowed myself to be messier with the application."

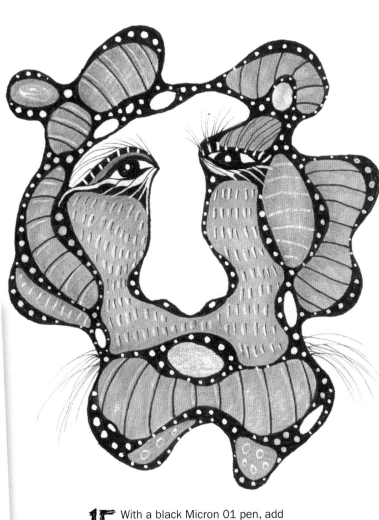

14 Add dots, lines, and other details with a white paint pen.

15 With a black Micron 01 pen, add lines for hair, or any other place you feel it is needed. You're done!

At 5:15PM, Carla has everyone bring their drawings over to the table and talk about how it felt to face the blank page and how we began to draw. Some started with one of their exercises from the morning, and others found inspiration from an image in a magazine. It was all about finding inspiration and then taking that and making it into something of your own, and it was amazingly successful; every piece was wildly different, and every piece took its inspiration from a different part of the day's work—the rocks in the planter, an ad in a brochure, the fish from the statue in the fountain outside Bally's.

"I know it's sometimes a risk to take a drawing class, and I really appreciate that you were brave enough to come," Carla says. Everyone claps and gathers up their work and heads off for dinner.

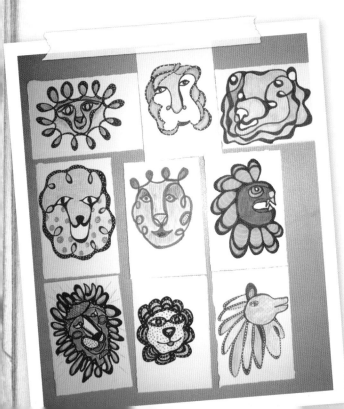

Tuesday evening is our "day off." While lots of people think the best way to approach art retreats is to cram every minute full of art retreat–related activities, figuring they can rest once they return home, other people—both teachers and students—believe you really need to schedule one day of down time, especially if you're in a location where there are lots of things to do and see, somewhere you might not get to return to any time soon. Las Vegas certainly qualifies, and it would have been great to take a whole day to walk around and see the sights. Unfortunately, we have only three full days in Vegas, and those have been pretty much filled up, so we try to cram a whole day's worth of sight-seeing into just a couple of hours.

We get stuck in Caesar's Palace, however, and that pretty much eats up the rest of the evening. Everything is decorated for the Chinese New Year, and there are so many things to look at and photograph that we stop every few feet. Then we wander into the shops attached to the casino and meet Derek, one of the Geniuses at the Apple store, and spend over an hour talking to him about iMacs and iPhones, and before we know it, it's dark and we're hungry.

There are lots of buffets and fabulous restaurants we haven't tried, but we want something nutritious and familiar, and a P.F. Chang's is right across the street. Of course, "right across the street" can be problematic on the Strip, especially with the construction that's going on along the sidewalk, but we finally figure out how to get to the restaurant and get inside where it's warm—it's gotten a little chilly outside—and we have a meal of one of my favorite foods: crispy tofu. Yum!

Wednesday, February 24

Classes continue today, but our time is up—we have to check out before noon, and we want one more trip along the Strip to look at the building facades. If you go to Vegas, schedule some time for this; the decorations are endlessly fascinating and inspiring.

We check out and get our vehicle and head out into the desert, back through Tucson and then, tomorrow, home. Adios, Las Vegas! It's been fun, and we've had a wonderful time, but I don't know that it's a city for me. There are too many people, and way too many of them are smokers—we're going to have to go home and launder even the clothes we didn't wear. While it's an exciting city, it can also be isolating and lonely. I can't wait to see what the Virginia incarnation of Art & Soul is like in May.

Note: I'm thrilled when Glenny announces that 2011's Art & Soul in Vegas will be at Green Valley Ranch Resort—a non-casino a little away from the Strip. You'll still get the fun and excitement without the smoke. Yay!

Time Off

Even instructors, for whom retreats are a part of their job, will often schedule a much-needed day off. Katie Kendrick tells us about a matinee of Cirque du Soleil, which is really popular. It's a break, but it's art, and it both refreshes and inspires your creative soul. Do a little Internet research ahead of time and see what you might want to include—visits to galleries, a concert, a lecture, or a tour. Think of your "day off" as part of your creative adventure. And when you need to rest, you need to rest.

Expect the Unexpected
Adorn Me!, Houston

WHERE: Embassy Suites, Houston, Texas

WHEN: Early March (Tuesday–Sunday)

WHO RUNS IT: Linda and Chuck Young

COST: Classes are priced individually, and rates vary ($100 and up). Lodging and meals are not included, but attendees get a special rate if they stay in rooms reserved for the event. The vendors' expo is $7.

SIZE: 150+ attendees, 55–60 classes, 15–20 instructors

This is the first year for Linda Young, organizer of Art Unraveled (see page 112), to host this all-jewelry retreat at the Embassy Suites in Houston. The retreat is new, the hotel is new, and many of the attendees are brand new to art retreats. The Houston Livestock Show and Rodeo is under way at the same time, proving that everything really *is* bigger in Texas: just for this rodeo event alone, there are 10,000 volunteers. Thank goodness Adorn Me! is a little smaller and more manageable than that with 20 teachers and around 150 students—94 of them from Texas—the perfect size for something new. Linda already has a full-time job in organizing Art Unraveled every year, so it's good to have something a little smaller and more laid-back, if you can call seven days of torching, sawing, pounding, and soldering "laid-back."

Monday, March 1

We arrive in Houston a little after 6PM, just in time to get checked in before the Meet the Teachers event, something I've really been looking forward to: seeing everyone all in one place, putting faces to online names, meeting new people, feeling the energy building. Opening night events are really wonderful: this is where you get to connect, see people you hadn't known were going to be there, meet your instructors. It's where you get your bearings and start to settle in.

When I walk into the lobby, I run into Jane Salley and her husband, Richard, both fabulous jewelry artists who are teaching here. We just saw Richard in Las Vegas, where he was teaching soldering and enameling, but we haven't seen Jane since last summer in Santa Fe, when we all met for dinner. While we're hugging, Thomas Mann comes over, and there's a whole new round of hugging, plus the inevitable exchange of everyone's favorite iPhone apps.

Tom and I talk briefly about Vendors' Night on Friday, where we'll be signing copies of *Creative Time and Space* in his booth. He's in the book, and it's always fun to do a signing with one of the artists.

And then it's time to Meet the Teachers. This is set up on the second floor. Tables ring the walls, and teachers have laid out some of their work, which is fabulous; everyone is oohing and aahing, and you know they're all wishing they could take every single class every single day so as not to miss any of this.

Linda welcomes us and introduces the keynote speaker, Jill Allison Bryan, a creativity coach. I'm set-

Richard Salley

Richard Salley explains why he loves art retreats: "One of the things that Jane and I most enjoy about teaching at the various art venues is the close camaraderie. These people have become for us an extended family. It is not an exaggeration when I say that we see some of our art friends more often than we see members of our own immediate family. We always look forward to getting together at the next event."

Opening Night

Some retreats have an official opening event, with sign-ins and name tags and a chance to meet everyone else. Some don't. If you're arriving alone, think about making a cool name tag to wear when you arrive. If you do metal work, make a metal one. Fabric? Stitch your name. If there is an opening meeting, do your best to be there. Sure, you're tired, you're hungry, whatever. But this first meeting, when everyone's filled with energy and excitement—you don't want to miss it. If there are trades, it's when the trading frenzy begins, and that alone is always worth the effort of hauling yourself off the bed and down to the meeting room.

tling in to take notes when The EGE sits down beside me and says, "I need you to find me a Best Buy so I can get a new camera battery."

Apparently it's our turn to have our own personal little catastrophe, this one being that Earl's camera—the one he uses to take the photos for the book—has decided to quit working. As in: won't come on at

all—refuses to power up. He's switched batteries, he's tested buttons, he's cajoled it and grumbled at it, all to no avail. This is kind of a big deal. We slide out as unobtrusively as possible, a difficult task given that I have on one of my jingly gypsy belts and sound like a herd of tiny belled sheep when I walk, and head out to find help.

I'll spare you the details. Let's just say that there was much gritching in the land. By the time we get back to the hotel, the ballroom is empty. Everyone has gone off to dinner or to their rooms, and we've missed all the excitement of opening night. After much more messing with the camera, Earl finally gets it to work and then treks off into the night to find some vitamin C and decongestant, because it has now become obvious that he's somehow caught a cold. He blames the secondhand smoke from Bally's in Las Vegas.

Tool Kit

Many workshops require you to bring a "basic tool kit." For jewelry classes, that might include needle-nose pliers, chain-nose pliers, jump rings, and beading wire. For paper-related workshops, you'll want a bone folder, scissors, a glue stick, and a craft knife, just to start. At Adorn Me!, the classes are all jewelry-related, so you'll want those tools; but for some of the classes, like Deryn Mentock's Paper Glazing, you're going to want your paper supplies, as well. Figure out what kinds of classes you're going to take, and then you can determine the basic supplies you'll need.

Tuesday, March 2

I love Embassy Suites. They're not cheap, but if you can afford it, they're a wonderful place to stay. Not only is there room to stretch out in the two-room suites, but there's the complimentary Manager's Reception each evening, with free drinks and chips, and the fabulous complimentary breakfast. This isn't one of those breakfasts you find in most chain motels with a couple of green bananas, a selection of stale pastries, and a stack of boxes of Frosted Flakes. No, this is a breakfast buffet that actually offers breakfast: eggs, potatoes, bacon, sausage, toast, oatmeal, cold cereal, juice, fruit, several varieties of yogurt. You can make your own waffles, and the coffee is hot and plentiful. It's a truly civilized way to do an art retreat.

Although wireless Internet is normally $8.99 a day, Linda has arranged to have it be part of the package for all attendees, which is also highly civilized and a big help to people who have to keep up with e-mail and their blog and Web site no matter where they are.

Today's the first day of classes. Linda and her husband, Chuck, are at the welcome table bright and

Keep a Healthy Perspective

No matter how we wish that big adventures would be smooth, there's almost always going to be some little glitch. Luggage lost, reservations bungled, workshops canceled. Instead of looking at your adventure as something that has to go perfectly or else, you've got to look at it as an adventure all the way through, glitches and all. Be prepared. Relax. Have fun.

early with their laptop and printer and all the name badges arranged neatly in rows. This, of course, makes me very, very happy: throughout the week, whenever I'm feeling particularly stressed, I can stop by the table and neaten up the rows of badges, straightening the edges in a little zen-like ritual.

In the evening, we hang out in the lobby, drinking free wine, eating salty snacks, and checking out what everyone did in their workshops. This is always where you wish you'd taken that class, and that one, and oh, *that* one, too.

Wednesday, March 3

Today I hang out in the office area—the space on the second floor landing where Linda and Chuck have their Base of Operations—and take notes and talk to people who come by. It's great because like The Store/office in Las Vegas, everything that happens comes through here. In the afternoon I go into some of the classrooms and shoot short videos of parts of projects. It's a lot of fun to have an excuse to sidle into the classrooms. Most of the instructors are totally cool with this—by now they're used to Earl coming in and taking photos. Some are a little uncomfortable with having someone else moving around, so we stay out and leave them alone. Either way is fine: different instructors cultivate different atmospheres in their space. Some like it very calm and private, and others like a lot of energy and chatter. It's great to move from one to the other and feel the energy change, noticing the different ways creativity flows.

Thursday, March 4

This is the day of Melissa Manley's Neptune's Necklace workshop. So exciting! We just met Melissa and already love her. She's calm and energetic, laid-back and excited—everything all at once in a personality that makes me feel right at home in her classroom. Then I notice that Earl is sweating. Beads of sweat are glistening on his head. My husband is not a sweaty kind of a guy, so I'm immediately on alert. I mouth across the room, "What's wrong?" and he shrugs and points to the camera with a look of both alarm and bafflement.

Oh, no. The camera has had another temper tantrum and, once again, refuses to power up. Why couldn't it have done this on either Tuesday or Wednesday, when we had nothing we had to do at a certain time and so could have dealt with it? But no. It was fine then. It waited until today to conk out on us, and now I have to try to fix it. I call the guy at the camera shop, and he recommends cleaning the battery contacts with alcohol. Nobody has any, so I hand Earl my little Canon point-and-shoot and snag the shuttle driver to take me to Walgreens for rubbing alcohol and cotton swabs.

David drives the shuttle for the hotel. As he's navigating Houston traffic, he talks about art. He's from Colombia, where art and crafts are a very important part of the culture. "Art is the expression of the culture of a country," he says. I realize how exactly right he is. And it's not just the art in the museums and the galleries. It's also the art being made in studios and workshops and basements and garages. The things people make are the indicators of what they value, of the tools and techniques that are important to them. Someday a historian may look back at the first few decades of the twenty-first century and note that there was a renaissance of metal working, of people hammering and shaping metal into pieces of wearable art.

We head back to the hotel with a bottle of rubbing alcohol, and I think back to a conversation I had with Dale. Her purse was stolen earlier in the week, right after she arrived in Houston. It was horrible and then it was wonderful when everyone at the retreat helped her look for the purse and drove her around to get a go-phone and gave her lots of sympathy and hugs.

"Am I the luckiest person alive?" she asked. And I'm finding that that attitude is so common among the people who attend art retreats, and it's key to having a great time. Things are going to go wrong: tons of water pouring from the ceiling, lost luggage, stolen bags, malfunctioning tools. You can't take this many people and tools and supplies this many miles from home, put them in an unfamiliar environment for a week or more, and expect that nothing will go wrong. The people who roll with it—who make do or borrow or go out and buy a temporary el-cheapo version of whatever it was—they'll go on to have a fabulous time. Dale took her classes in between interviews with police officers. Earl and I deal with the camera. But the way to look at it is: how lucky we are to be here. Having the time and resources and opportunity

to leave home and take classes with other creative explorers who are interested in the same things you are? It's not about having everything be perfect and easy and smooth. It's about figuring out how to make sacrifices and make things work so we can take advantage of any opportunity to take classes and meet people who love the things we love.

By the time I get back, Earl has the camera working again, although who knows for how long. Whatever. We settle in and focus on Melissa's excellent workshop, drilling, whapping metal washers, dipping things in patina. Way more fun than worrying about electronics.

Expect the Unexpected

Linda tells me this is the key to organizing an art retreat. Whether it's just you in your basement with a couple of friends or a brand-new jewelry event in a city far from home, you've got to be prepared to roll with it. Linda says you have to have a good sense of humor. She tells of checking out the classrooms as they're being set up and finding that none of them has wastebaskets. Or finding out that they'd set up glass-topped tables in rooms where people are going to be hammering metal.

But is it worth it? Oh, yeah. Because most of the time "the unexpected" is about the class proposals that just blow you away, or the generosity of the attendees and their willingness to help each other, or the kindness and professionalism of the hotel staff. Expect the unexpected, and prepare to be happily surprised.

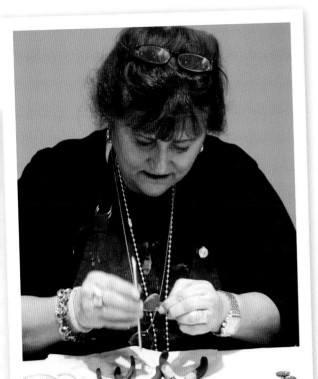

I've gotta tell you, metal has always scared the crap out of me. I love it—I love jewelry, I love little metal boxes, I love gears and bolts and those little bits of whatever that look like little stars. But working with it? *Yiii!* I think, if you want to know the truth, it's a Fear of Tools. Those things are scary—especially the saws. And the awls. And the drills. And. . . .

But when I saw Melissa's fabulous Neptune's Necklace and read about tube rivets, well, I *adore* rivets. I can't make rivets, seeing as how that involves various kinds of scary tools, but I think they're just the coolest things ever. So when Melissa taught her workshop, we were there.

Neptune's Necklace
with Melissa Manley

Class Supply List

washers (we use copper washers here)

small hammer

metal alphabet stamps or other metal stamps for texture (optional)

liver of sulphur

plastic containers, 2 (one for liver of sulphur, one for water)

old tweezers for dipping washers into liver of sulphur

paper towels

copper tubing (small)

drill and drill bit the size of the tubing

images that will fit inside the washer "porthole"

mica sheets

scissors

circle punches the size of your portholes (optional)

circle template (optional)

metal block

flaring tool for making tube rivets (eyelet setter or round-end dapping punch)

scribe or sharp tool for tracing circles

fine-tip permanent marker

jewelry files

cutting mat (or piece of leather or mat board scrap)

bench block and bench pin

wooden ring clamp

jeweler's saw and 2/0 blade

black wet/dry sandpaper for metal (320 grit and 400 grit)

jump rings

chain or wire for making chain

Melissa starts us out with an introduction to tools. It turns out I'm not the only one who's just the tiniest bit intimidated by power tools, and Melissa takes time to explain the ones we'll be using. Her hand tools are just the coolest, and she explains those, too, getting everyone comfortable with the idea of using tools on metal before we begin.

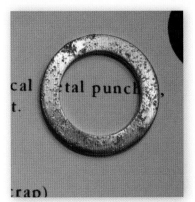

1 Texture one side of your washer using your hammer. Only one side will show, so you really only need to do one. You can use just your hammer, or you can use a hammer and a punch or other tool.

Texturing

Melissa likes to hammer on concrete when creating texture, so everyone goes outside and puts the washers on the driveway and pounds them with their hammers. This is a *great* way to start the morning! You can try creating texture by pounding on your own driveway or sidewalk or other textured concrete, brick or rock surface.

2 Use metal stamps to stamp letters or shapes on the washers, if desired. Put the washer on your metal block, hold the metal letter in place, and hit it firmly with the hammer. Melissa says, "Don't lift up the stamp after hitting it! Rock it gently forward and hit it again to get a full letter or image." Keep in mind where you're going to be drilling the holes for the rivets.

3 Use a file or flexshaft or black wet/dry metal sandpaper to smooth any sharp edges that resulted from the hammering/texturing. This is a bit easier if you secure the washer in a ring clamp to hold onto it.

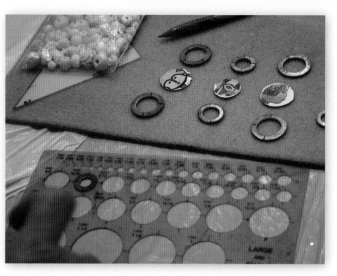

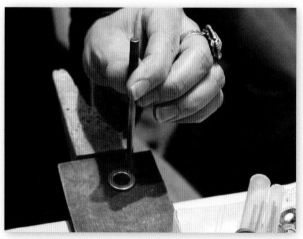

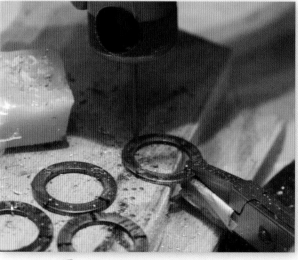

4 Use your washer as a template to trace around on a piece of mica. When you cut out the mica (you can use scissors, but don't use your sharpest pair), cut it just a tiny fraction inside the line. Trace and cut out two pieces.

5 Cut out an image that will be seen through the hole in your washer. You can trace around the washer, just like you did on the mica, or you can find a circle in a circle template that matches the size of your washer and use that to trace with instead.

6 Back to the washer. Use the center punch and the hammer to make a little divot where you'll drill the holes for the rivets. You'll drill four holes: at 12 o'clock, 3 o'clock, 6 o'clock, and 9 o'clock.

7 Drill the holes in the washer at the divot points.

8 Use the washer you just drilled as a template to drill one hole into the other washer. Line up the washers and drill all the way through, making the hole at either the 3 o'clock or 9 o'clock position. You won't drill the other three holes in that second washer until you've riveted the first hole (coming soon!).

Note

Melissa says, "When drilling, try to stay perpendicular to your washer and not drill at an angle. Angling out could cause you to miss the edge on the backside. If you already have one, a drill press would be great for this. Also, you don't always need speed. Be sure the bit is biting into the metal. You should see two little curls of copper appearing as you drill. If not, be sure you're applying enough pressure and that your bit is sharp."

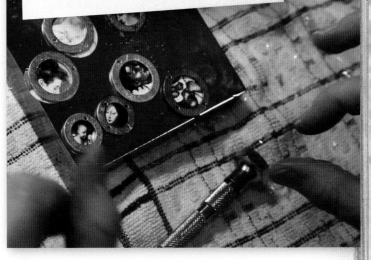

9 Patina the washers using liver of sulphur solution that you have poured into a plastic container or cup. You don't need to leave them in the solution very long, especially if the solution is freshly made with warm water. Hold the washer with your tweezers and dip each one briefly into the solution. Rinse in a container of clear water and pat dry. Then use fine sandpaper to remove the darkened solution from the surface of the washer, leaving it in the lower, textured part. If you sand off too much, you can repeat the process until you get a combination of dark and light that's pleasing to you.

10 Sandwich the image between the two pieces of mica. Use the first washer again as a guide to create holes through the stack, at the same hole you drilled for the second washer. Build a sandwich of the washer with the four holes in it, the stack of mica and image, and the other washer (with one hole). Use an awl or drill bit to ensure the holes through all three layers are aligned, then hold the sandwich together with the ring clamp.

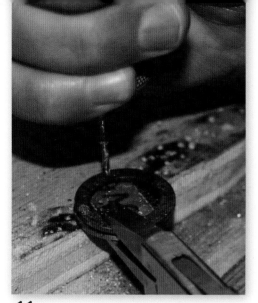

11 Insert the drill through all three layers to clean up any bits and ensure everything is aligned.

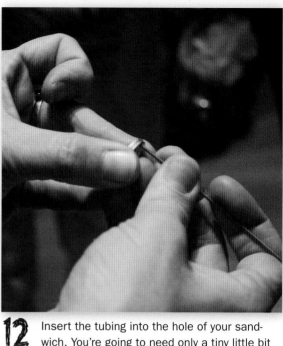

12 Insert the tubing into the hole of your sandwich. You're going to need only a tiny little bit of the tubing to stick through to form the rivet. Melissa says, "The textbook rule of thumb is one-half the diameter of the rivet material should stick out of the hole." So if your tubing is ⅛" (3mm) in diameter, you should have $\frac{1}{16}$" (1.5mm) of tubing sticking out. Use a fine-tip permanent marker to mark where you're going to saw the tubing.

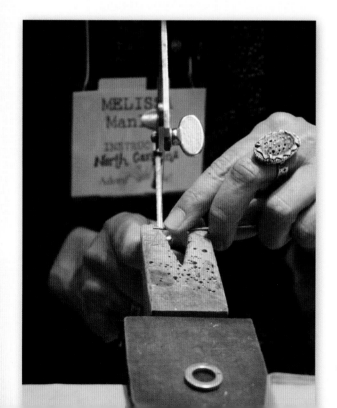

13 Load your jeweler's saw with a 2/0 blade, making sure the blade is taut. You can use a tube-cutting jig from a jeweler's supply or use a round file to file a groove in your bench block to lay the tubing in to cut it. You need little or no pressure to saw, just a gentle pulling of the saw against the tubing.

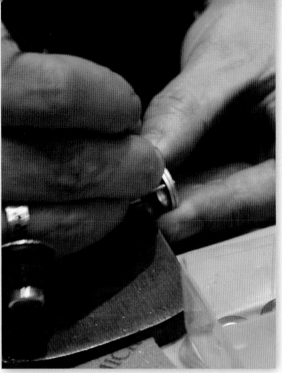

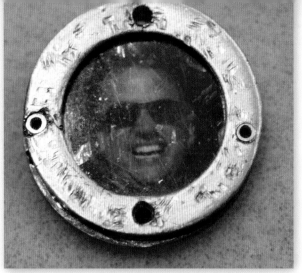

15 Form the rivet by inserting the dapping punch or eyelet setter into the end of the tubing and tapping it lightly 4 to 5 times with the hammer. Flip the sandwich over and splay the other end of the tubing the same way. Flip back and forth, tapping each side just a couple of times before flipping again.

Once you've gotten the first rivet set, go back and drill the hole through the remaining layers for the other rivet (opposite side) and the holes for the jump rings. Set the second rivet as you did the first. Create more portholes following the steps above and then add beads, shells, charms—whatever you like—to complete the necklace, joining the portholes with chain.

14 Insert the cut tubing into the hole in your washer sandwich.

Practice Makes Perfect

Melissa talks about how to approach the sometimes-steep curve in the learning process: rather than thinking, "I have to do this over and over," you think about how "I *get to* do this over and over." It's a process you want to learn and master, and so you take the time to do it again and again, learning it in a very calm, peaceful way until it becomes second nature. Melissa says, "Work can go from something we may dread to a process that brings us great joy. Metalsmithing processes can be, and in fact should become, as meditative and satisfying as throwing pottery on a wheel or practicing yoga."

Note

In cutting metal, you don't push the saw into the metal. You lean the teeth of the saw against the metal and stroke it so that the teeth of the saw can chew through the metal. Melissa says, before you begin, you want to get loose and relax.

"The more I work with metal, the more I enjoy the process of lightening up."

Friday, March 5

The most important thing I learned from Melissa's class was that metal work isn't the hard, scary process I imagined. I'd always thought I'd have to fight with the metal, force it to do my will. Melissa showed us that, with the right tools and the right attitude of patience and confidence, there's almost no physical force involved. You don't have to overwhelm the metal; you simply learn to work with its properties.

Today is supposed to be our day to check out all the workshops and take lots of photographs, and we've really been looking forward to that. Instead, we head out early, armed with a list of camera shops. By the end of the day, Earl has Camera #2. With that off our minds, we can relax and enjoy—yay!—Vendors' Night, known here as the Adorn Me! Expo.

A couple of the large classrooms have magically been transformed into one huge room filled with tables and chairs and lots and lots of fabulous jewelry and supplies. I set up at the end of Tom's booth, the perfect spot to watch the crowd shopping and see how much fun folks have trying on Tom's jewelry.

Saturday, March 6

I talk to Linda and Chuck about how they began Art Unraveled. They came to Houston in 2002 to attend Darlapalooza, a now-defunct art retreat sponsored by Darla Pruitt of Eccentricities, a rubber stamp store that used to exist in Spring, just outside Houston. Chuck came along for the ride, but Linda somehow had two conflicting classes, and Chuck found himself in a workshop full of women making Altoid tin dolls. He discovered it wasn't bad at all, and on the way home, they got to talking about how much Linda hated having to travel all over the country to attend art retreats when they lived in Phoenix, the fifth largest city in the United States. It has restaurants and shopping, an airport and hotels—and those hotels were willing to make great deals during the hottest part of the summer, when temperatures top 110 degrees and not a lot of vacationers are willing to brave the heat. If you hold the retreat in a nice hotel with a lounge and pool and restaurant, and nobody really ever has to leave once they check in, well

So they started planning the first Art Unraveled. "We started in March," Linda says, "and held it in August. I organized the whole thing in six months." She shakes her head, finding it hard to believe even now, seven years later. Now, of course, with Art Unraveled in August and Adorn Me! in March, planning the retreats is a full-time job.

So You'd Like to Host an Art Retreat

Retreat planning is not for the faint of heart, or for the disorganized, the lazy, or the clueless. It's a tough, heady, exciting, anxiety-producing full-time job to plan and organize the largest retreats, and even the smaller ones take many, many hours of work and call on skills ranging from schmoozing to financial juggling.

If you want to host a local retreat, the best advice is: do your research and then start small. Find out what's available in your area and go from there. Where will people stay? Where will the workshops be held? What will people eat, and where? What will people do in the hours they're not in class? Make lots and lots of lists and ask lots and lots of questions. Also make sure you know about contracts and legal issues. Linda says, "If you don't understand them, get somebody who does."

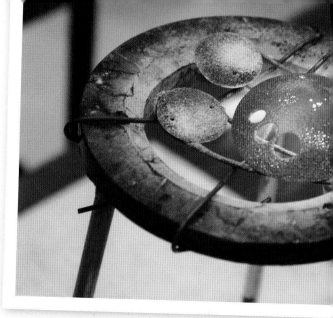

Sunday, March 7

Today we hang out in Richard Salley's Enameling 101, a workshop that has everything: jewelry, lots of color, tons of tools, and fire. With torches! What's not to love? Lots of people have the idea that art retreats are filled with classes where women make greeting cards or scrapbooks. They have no idea of the workshops that are offered or of the level of skill of the instructors. This is especially obvious here at Adorn Me!, where working jewelry artists are teaching the skills that allow people to create their own jewelry, the kind you'd pay hundreds of dollars for in a gallery or boutique. This isn't about hot glue and pipe cleaners, not by a long shot.

And lots of these classes are perfect for people who like to work with tools, as well as fire and saws and stuff that's maybe just the tiniest bit dangerous. Do I need to say that Earl spends all day there taking photos? This is another workshop he would have signed up for if he weren't working. Poor guy—he misses a chance to play with fire, but he does get some fabulous photos of it.

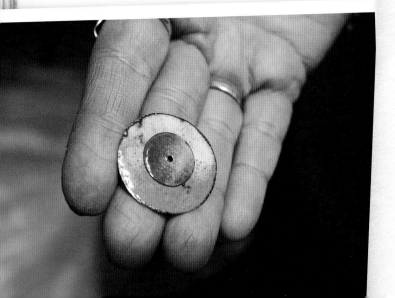

Working with Fire

Diana Frey, who is teaching her "Twisted Sistah" necklace class, offers these tips for working with a butane torch:

- Work in a well-ventilated area.
- Be sure the area is cleared of all things flammable.
- Work on a heat-resistant surface.
- Wear safety goggles.
- Always be aware of where you point the flame.
- Tie back long hair and roll up long sleeves.
- A protective apron is also helpful.

Monday, March 8

Today we leave for home, packing up and saying good-bye. I'm thrilled that this first Adorn Me! was such a success. That means it will be back again, here in Houston, next year. Yay!

On our way home, we stop in San Antonio and buy yet another camera for Earl, this one gently used and well cared for by the wonderful Nan Spring. Now Earl has a camera, a back-up camera, and a spare. Artfest is next on the list, and you don't want to be out on an island with only one not-too-reliable camera.

Sunday night is the Show & Tell & Adorn Me! Banquet. After Keith Lo Bue's class is over at noon, workers come in and convert his classroom back to its function as a banquet room. On one side are tables where attendees set up their finished pieces from the classes they took—gorgeous work, indeed. After a fabulous meal of sirloin and chicken fajitas, black beans and rice and mixed vegetables that ends with both flan *and* chocolate cake (oh, my!), Keith presents "Through the Hedge Maze," a talk and presentation of images that show how he works. I love this—there's nothing more fascinating than seeing how an artist starts from nothing but an idea and a few pieces of what most people would think of as "junk," and alters those pieces and adds to them and transforms them, seemingly by alchemy, into something marvelous. Listening to Keith talk about how he works is both captivating and inspiring. It makes you want to run to your studio and start sifting through your own collections.

Room with a View
Artfest, Port Townsend

WHERE: Fort Worden, Port Townsend, Washington

WHEN: Late March or early April (Wednesday–Sunday)

WHO RUNS IT: Teesha Moore, with help from her husband, Tracy, their daughters, Tiphoni and Trista, and a host of their friends and family

COST: $490–620, which includes three workshops, lodging, and meals

SIZE: 550+ attendees, 28–30 classes per day for 3 days, 37–40 instructors

Artfest is the granddaddy of the art retreats, the first and the biggest, an experience you really don't want to miss. If you can go to only one art retreat, you really owe it to yourself to experience Artfest. This retreat at Fort Worden is set far away from the hustle and bustle of Regular Life, on the very northeastern-most tip of the Olympic Peninsula across Puget Sound from Seattle. Although you can get there from land if you're averse to traveling by water, the easiest—and most exciting—way to get from Seattle to Port Townsend is by ferry. Getting there is an adventure in itself, but it's only the first of many adventures in the magical experience that is Artfest.

Sunday, March 21

For most people, Artfest begins in September of the previous year when they get their confirmation packets in the mail. For us, it begins with driving to Dallas, where we spend the night before catching an early flight out in the morning. And realizing that one of us—the one who is *not* me—has forgotten his cell phone. [Surprisingly, we will discover this isn't a very big deal, although it provides the opportunity for *lots* of teasing.]

Monday, March 22

Today we fly out of Dallas. I'm a gritchy, miserable flier, and that tells you how much I love Artfest: I always swear I'm never going to get on an airplane again, and then I get another chance to go to Fort Worden, and the next thing you know I'm booking a flight. And getting on an actual airplane. We'll skip the part about the toddler a couple of rows ahead of us who cried and kvetched and screamed pretty much the whole four hours. And the nasty, hateful woman at the rental car counter and the icky SEATAC airport hotel where we spent the night. We'll forget all that. Why? Because tomorrow we head to Port Townsend, and I can't wait!

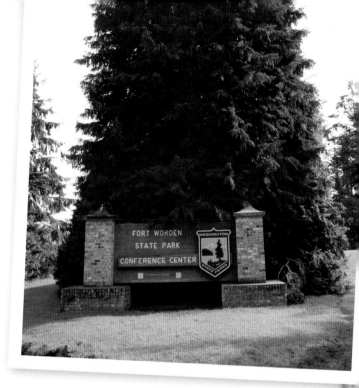

Tuesday, March 23

The adventure of getting to Artfest begins, for most people, with the ferry ride, whether you get that far by plane and taxi or just driving from your house across town. Teesha couldn't have planned it any better, this whole long series of things you have to do to get from wherever you are to Artfest itself, like a scavenger hunt or a Quest. The anticipation builds and builds and builds.

We catch the Wenatchee Ferry, ride across to the island, and drive our little rental car up Highway 3 to Port Townsend. It's a picturesque little journey, especially for those of us who don't have a lot of big trees in our part of the world. In Port Townsend, we check into the Palace Hotel, a former bordello where each room is named after one of "the girls." We get Miss Pearl, with a lovely view of Port Townsend Bay.

47

Packing and Dressing for Artfest

If you're from the Olympic Peninsula or from some other place where it's always cold and damp, then never mind. You can skip this part. But if you're like me and arrive from someplace where you have, you know, actual sunshine—plus heat!—well, read this: the Fort is cold. It's cold outside, and—in my experience—it's often cold inside as well. If you're cold-natured and tend to get chilled easily, you're going to need to plan ahead so you can relax and have fun instead of trying to keep warm. Think layers. Some classrooms are warm, so you'll want to be able to take stuff off if you get hot.

The beach at the Fort is absolutely wonderful, but it is not a warm and sunny tropical beach. It's often misty and drizzly, and to really enjoy it, you're going to need waterproof shoes and something to cover your head (and don't forget a baggie for collecting shells because, honey, your pockets just aren't big enough. Guess how I know this?). Bring warm socks for when you get back to your room. A robe or thick sweats for chilly mornings and late nights hanging in the common rooms (remember: the dorms are women-only, so you can hang in your footy pj's). A jacket. A sweatshirt. My advice? Wear as many of these layers as you can on the flight to save room in your luggage. Plan ahead, and you'll be fine.

I have been to Artfest three times, twice as a teacher and this time doing research, and Earl and I have stayed in three different places. The first year we were in Madrona, one of the larger houses at the Fort. We couldn't stay in a dorm—men aren't allowed in the dorms during Artfest. That's OK because the dorms—and, it turned out, Madrona—are not for me. Sharing a bathroom, freezing to death because everyone else wants the thermostat set on 60. Eh. Not my way to enjoy a retreat. Others, though, love it. It's like camp, but indoors. So if you loved camp, you're in luck!

The second year, we stayed in one of the officers' houses, and that was the best: Teesha gave us a room that had a bathroom all its own. Alas, this room is saved for a teacher each year, so it wasn't available for us this trip. Instead, I chose a hotel in town, figuring I should report on that option, too. The funky and historical Palace Hotel was perfect for us, but beware: with no elevators, it's not for everyone. Think schlepping your suitcases up and down very old, very steep stairs. Good exercise, but whew. Fortunately, there *are* other hotel options if you prefer an elevator.

Wednesday, March 24

I can hardly wait, but registration doesn't start until 3PM, so we have a big chunk of the day to fill. I work at my laptop for a while, drinking coffee and sitting in front of the sunny window. The glass is old and kind of ripply, and the sun shines on the water across the street. It's lovely, and I finally can't resist any more, so I put on a bunch of layers of clothes and head out to explore Water Street. Just across from our hotel is Wynwoods Gallery and Bead Studio, owned by Lois Venarchick. I'm checking out her fabulous hand-made sterling earrings and happen to look down at the small display of books. Whoa! There's *Creative Time and Space* sitting right next to Tonia's book, *Plexi Class*. I introduce myself to Lois, and she reminds me that she had the very first copy of the book on her shelf, back before it was actually released. This is so cool, but it's not like I needed another reason to buy earrings from her. I buy a lot of earrings during the next few days, in fact. She does marvelous work.

The Dorms

The dorms are, well, dorms. They're not the fancy-schmancy dorms you might be used to from university. You get a simple single bed, a built-in desk, and a place to store your stuff. And a window, some of which have spectacular views. You'll share a bathroom with a bunch of other women. You may want a portable reading light, and you'll need an alarm clock if you don't use the one on your cell phone. You might want an extra blanket or your own pillow. If you start a list of things you need to be comfortable and it goes on for a couple of pages, you might want to think about staying at a hotel in town.

Lisa Myers Bulmash

"Going to Artfest means I'm making an investment in myself as an artist. And it's kind of expensive—money, sure, but there's also the time and mommy guilt, even though my husband is my biggest fan. I'm still leaving him with our two small children while I'm off doing things that have absolutely nothing to do with them.

"But once I'm on the ferry heading to Fort Worden, that part of my world recedes as Artfest comes more into focus and grows more intense. I'm not a different person, exactly; I'm more intensely the person whose identity is not defined by marriage, motherhood, or salaried work. You might've heard the expression, 'let your freak flag fly.' It means, for me, telling my stories through the art I make, no matter how weird or private or outside other people's experiences, in an atmosphere actively encouraging me to do so, where people I've met in previous years can't wait to see exactly how freaky that 'flag' is.

At the next Artfest, I'll be rooming with two Artfest pals from Canada and an old friend I've known since third grade—Tally Oliveau. Being able to share the art I love at such a life-altering retreat makes these friendships that much sweeter and deeper."

We get to the Fort in time to watch people arrive, leaving their luggage in front of the Commons and lining up outside the room where they'll register, pick up their packets and room keys, and do a little pre-event shopping (there are always t-shirts or sweatshirts or aprons or totes, and they go reallyreallyreally quickly). It's so much fun when the doors open and people start streaming in, greeting each other with lots of squealing and hugging. Even the shy newbies are swept up in the excitement. I do a lot of squealing myself when I run into Lisa Myers Bulmash, whom Earl and I met at Art & Soul in Portland in 2007 when we stalked her, trying to see if she really did look exactly like our niece. (She did not, actually, and luckily for us she had a sense of humor about being followed around by strangers.)

Meals

Some people love the food, and some people grouse about it continuously, but even a picky eater like me has to give credit to the cafeteria staff in the Commons for their effort to provide a variety of fresh, healthy food for all kinds of diets, from "regular" to vegan to diets with special restrictions; they try to provide at least one or two dishes that almost anyone can eat. If you have a really restricted diet, you'll want to check before you sign up for the meal option, but most people will be able to find food to suit their needs. You can sign up for three meals a day or just for breakfasts or just lunches or any combination. Signing up for meals is worth it just to get a hit of Artfest excitement every day, because it's the one place you're sure to see almost everyone, sooner or later. Keep in mind that it's a cafeteria and not a four-star restaurant, and you'll be OK.

After checking in, people hurry off to their dorms—many do a lot of groovy decorating in the common areas. And then it's time for dinner, served every evening from 5:30–6:15.

After dinner is the kick-off meeting from 7–8PM. It's always fabulous because, again, it's the energy. I can't do justice to this, no matter how hard I try to describe it. The energy at Artfest is amazing. I don't mean crazy energy with people rushing around, frantic and scattered. No, I mean the energy you get when a bunch of creative people have a block of time carved out to spend with each other doing what they love best.

Shared Gratitude

It's not just the attendees who feel grateful for their experience. As Teesha put it, "I felt it was important to have a gathering where we could all be artists for a few days and be inspired by each other. I get the best people coming to my events, and I am so grateful to each and every one of them."

Thursday, March 25

This is our day to take Jesse Reno's painting class. I know nothing about painting, so this is really exciting for me. His workshop is in a big room with tons of light, and every seat is filled. Jesse's workshops are really popular, and I quickly discover why.

As a special treat after the introductions and instructions and business stuff, Teesha brings in a band. Surrealized seems to be a wonderful band, but the music is *way* loud, and a lot of us head back up to the dorms where opening-night parties have already begun. We stop in at several of these, where everyone is chattering and hugging friends they haven't seen since last year, swapping trades, wearing hats and wigs and decorations. Eventually it's all just overwhelming, and Earl and I find the rental car and drive back into town to our hotel, exhausted and ready for bed. Back at the Fort, on the other hand, many of the celebrations go on well into the wee hours. Oy.

Free to Create
with Jesse Reno

Jesse explains that when he paints, he gets paint down on the paper and then starts "looking for images and ideas that are personal; the idea of the piece telling you a story by following out the ideas that come and pass through your mind while painting and looking at your work." He's full of energy, fueled by caffeine and inspiration, and his workshop buzzes.

You'll start by finger painting. Jesse says, "There should be no expectations. If you paint with your hands—and you probably haven't done that in quite a while—you connect with the paint. The more you can remove the expectation of what you're doing, the more you're in the moment, whether it's painting or life. Start with the paint—and your fingers and your hand." That's why Jesse gives you dollops of inexpensive paint on a paper plate and no tools except your fingers. If you can create something you like out of those things, then you're going to feel really good about it.

Class Supply List

sheets of heavy paper: 1 large, 1 medium, 2 small (exact size isn't important, but the larger you can get, the more room you'll have to paint)

acrylic paint: blue, yellow, red, black, white (Jesse uses Blickrylic. It's inexpensive, nontoxic, and comes in big bottles with squirt tops—always a good thing)

Lyra Color Giants black pencil

Cray-Pas pencils: sienna, blue, white

paper plate

paintbrushes and mark-making tools (optional)

1 Put a little of each color on your paper plate palette. You don't want a whole lot of paint; it's better to put less than you think you'll need and then come back and get more than to put so much that the paint starts making a big pool. Leave some space between the colors—they'll begin to blend as you work.

2 Put a little of one color on your hand or your fingertips and apply it to your paper. You don't want to apply it carefully and precisely. Look at how Jesse does it: His hands are always a blur (and he's always talking at the same time—huge energy!).

Add another color, randomly placing it on another area of the paper. The colors can overlap or not. They're going to start blending on your hand, anyway; you're not washing your hands between each color here.

3 Repeat with each of the colors. You can deliberately mix the colors on your fingers. Jesse recommends using a lot of white. He uses white the most, then the other colors, then some black—he uses black the least. Jesse likes what he calls "pretty colors," not dark, ugly, muddy colors, and he advises finding the areas where pretty colors appear and keeping them, while painting over the places with swamp colors. Unless, of course, you're fond of swamp colors.

Use yellow last because it's translucent. Keep working the colors in until most of the surface has color on it.

Note

When picking up paint, you don't want a big glob that's dripping off your fingers. While you're not working totally dry, you're definitely not working really wet either. You want to be able to put the paint where you want it without it running and pooling and puddling. Then you would get what Jesse calls "swamp colors."

4 Look at what you've done. "Even if you don't like most of it, there's something that you like," Jesse says. Take your fingers and make a box with them and use that box to look at various areas of the painting. Pick one area that you like; block out parts that you don't like.

Put two colors on your fingers and let them mix as you rub your fingers across the paper. Jesse says, "Ninety percent of what makes a color look good is what's next to it. If you look at my work, 90 percent of the time, hot and cold are next to each other. I'm really into that. Level two of that is light and dark. Hot to cold, light to dark. It relates to pretty color."

Work on making the colors pretty. If the color is ugly, put some other color over it. If the color is OK but not pretty yet, put another color next to it. At this stage you want to get rid of the parts you don't like, the ones that stand in your way and bother you. Start building up layers. There's no other way to get that level of color complexity. Most people are afraid to paint over something, even if it's something they don't really like. Jesse paints over these not-so-favorite parts with abandon.

Note

Jesse talks about the importance of being willing to change things. Paint over it, put other colors on top of parts of it, put chunks of color next to it. Keep working with it until you DO like it. It's just paint—cheap paint, in fact—and you can keep adding layers and covering up the parts you don't like until you're satisfied with what you've done. This may take a while; relax into the process.

5 Put paint on your finger and make some dots on a large area of the painting. Since you aren't cleaning your fingers, "white" dots will be a sort of blueish white, or reddish. The point is to add another layer of color and some texture. If you get stuck, flip the canvas upside down and look at it from that perspective. Move back from the piece—step away from it. You can't see what it is when you see it only up close.

Find a part you really like and start thinking about what that might be. A mouth? Eyes? A figure? Pick a color that's the opposite of that area—so it will show up—and paint around it. You can draw with your fingers, adding shadows and shading.

Now you're going to start zeroing in on a focal point. It doesn't matter if you know what it is or not; you're just picking one of the areas you like and isolating it and starting to work with it. You're creating an image from the background. In your finished piece, the inside part of the image will be what started as this first part of your colored background.

You'll choose this shape, isolate it, and then paint over everything else, which will then become the background of the finished piece. So the part you've painted already will show only in the inside of your chosen shape, whatever it is. Jesse talks about looking for images that are personal.

Note

Jesse says, "Ideally, when you practice this at home, I recommend you work on more than one painting at a time. Five different palettes, five different canvases. One thing is feeding another." Another benefit of this, he says, is that you can let one painting dry while you work on another.

6 The pastels (Cray-Pas pencils) are colors that aren't like the ones in your paint palette. You've got the white, which is light; the sienna, which is hot, and the blue, which is cool. Use these to make some marks on your canvas—dots, flowers, spirals. Don't worry about it; if it doesn't work out, you'll paint over it. This part is intuitive—maybe you're starting to feel something happening, maybe you're not. It doesn't matter; you're making marks, adding texture, starting to embellish.

Choose one of the pastels to outline the shape. Look at the colors around the shape and determine what colors would best emphasize those. Keep working, redoing the parts you don't like, enhancing those you do, moving back and forth between areas and, if possible, between several paintings.

Now's the time to add line work, dots, embellishment—whatever your piece needs to move to the next level.

Jesse understands completely how it feels at this stage, saying, "Is it ever going to become something? It could become something just like that, or it could never become something. It could become something in two seconds, whether by accident or on purpose." It's a mix of following your intuition and knowing what you like and what you don't like and following what you like. Lots of people in the workshop today find a face in the middle of their sheet of paper.

Here the workshop is interrupted by a fire alarm. All the flashing lights go off, all the buzzing sirens shriek. Everybody jumps at the noise and then quickly goes out the door and down the stairs. Surprisingly, everyone's able to get back to work as soon as they let us back in, even after 20 minutes of standing out in the cold and damp.

Note

Jesse says, "You don't want to pick an image—say, a fish—that's just a solid shape of one solid color, because after you work on the background, you'll have a solid purple fish. This isn't nearly as effective as a fish that has something going on inside it—purple and red, maybe, or purple with blue spots and areas of reddishness. Look not for the solid, definite shapes but for the shapes that are made up of layers and areas of texture that are going to make it really interesting."

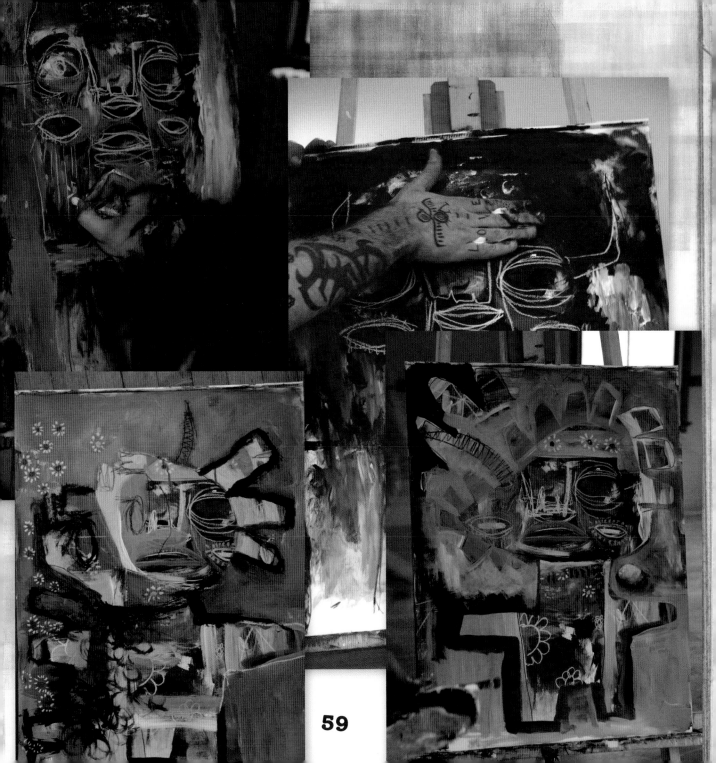

When everyone gets "there"—a stopping point or pausing point—Jesse has them try a series of "break time" exercises with the Lyra pencil and a piece of bond paper. These remind me of the exercises we did in Carla Sonheim's drawing class in Las Vegas.

Break Time

1. Fold two pieces of paper in half from top to bottom and stack them so you have a little booklet with four pages.

2. On the first page, draw a face.

3. Now open up to the second page and hold your pencil in your clenched fist, as if you were going to stab a knife into a block of cheese from overhead. Draw another face.

"It puts you more in the moment of drawing a line," Jesse says of holding your pencil this way. It takes you away from thinking about drawing a face. He says that if you hold the pencil like you're a three-year-old, you can draw a face like you're a three-year-old, which can be awesome. He asks, "Does that feel better? Just wait!"

4. Now move to the third sheet and hold the pencil in your nondominant hand. Hold the pencil however you want. Draw another face.

He tells about drawing with a friend, when they held their pencils in the wrong hand and just started drawing animals. "It just looks so much more genuine to me."

5. On the last page, draw a face without looking at the paper, or mix up the techniques—nondominant hand without looking, clenching the pencil with the wrong hand.

6. Go back and add embellishments, play with the sketches until you feel looser, and then go back and work on whichever drawing feels ready or all four at once.

At this point in the workshop, Jesse moves around the room and does a quick critique, holding up each piece, asking what the artist thinks about the piece, and then opening up the discussion for other comments. He does this easily and quickly, not giving anyone time to hyperventilate over the idea of A Public Critique. His comments are encouraging and helpful, and he tells what he might try if it were his piece, always sticking to his insistence that staying loose and not obsessing over each individual step is the only way to get anywhere. "Just boom! Boom, boom, boom, boom!"

Jesse asks, "Where's it going? Who knows?" This isn't a project with a specific end point, where you do The Final Step and you're finished. At the end of the day, Jesse's piece looks finished, but he says he'll probably work on it some more.

Although Jesse could have stopped at several points along the way, he can also keep going, covering up parts of the painting with more and more layers for as long as it continues to evolve. And that's the beauty of being Free to Create.

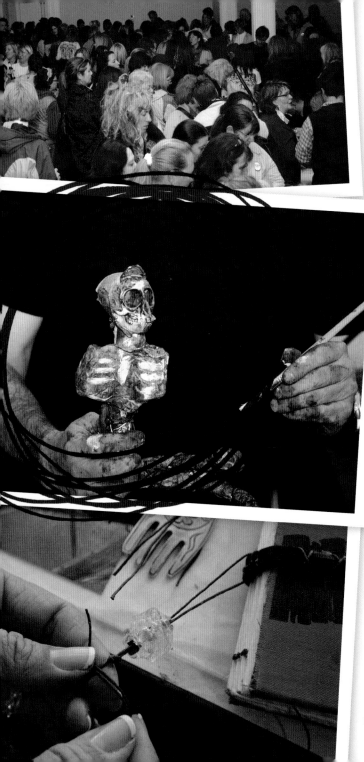

After dinner, we have three options for evening entertainment. Jesse's band, Power Circus, is playing at the Undertown Coffee house starting at 7:30. From 7 to 9PM, there's the first-ever Iron Chef Artist Challenge, and from 7 to 10PM, there's the much-loved annual Beach Bonfire and Journaling Party in the Kitchen Shelter. Whew. We manage to make the artist challenge and the beach party, but miss hearing Jesse's band, alas. We thought about splitting up to cover everything, but didn't know how we'd find each other again, seeing as how one of us—ahem—doesn't have his cell phone with him. As I said: endless opportunities for teasing. (All during Artfest I tell various people to ask Earl for his phone number so they can call him if they see a good photo opp. I find this hilarious, as you might guess.)

The artist challenge is great fun. Each participating artist in either 2-D or 3-D is given a packet of materials and a time limit to create a masterpiece (or at least something that they're not embarrassed to show off). Surrealized plays on the stage, and a huge crowd mingles, taking photos of the artists at work and trying to get close enough to see the details of making. That's the beauty of this. It's not so much about what each artist creates as that it's a rare opportunity for people to watch some of their favorite artists at work. How do they start? What do they do first? How does Artist A's approach to this pile of stuff differ from Artist B's? This is definitely going to be a regular part of Artfest, you can tell: there's more good energy in this room than in any one place I've ever been.

The Beach Bonfire and Journaling Party is great fun as well. There's a fire outside, but because it's misting and, at times, actually raining, most

people stay in the shelter, where there's a fire in the stove, beer and wine to be had, and lots and lots of shared journaling. The band members stop in, which really ups the percentage of men and results in some lighthearted flirting that's lots of fun to watch from a comfortable seat in an old lawn chair.

Friday, March 26

Today we hang out and check out classes. Earl goes back and takes more photos of the pieces Jesse worked on yesterday in class, discovering that it's hard to even recognize them. Jesse has changed them so much that they're completely different paintings, which is really cool and emphasizes his belief that nothing in the painting is sacred—everything can change.

Earl gets great photos in Katherine England's mosaic workshop in the Kitchen Shelter on the beach, where light pours in the windows and makes the glass sparkle. The portraits the students create are amazing!

Katherine England

"I enjoy the retreats because they attract people seriously engaged in the conversation of creating. At Artfest my challenge is to keep one step ahead of these empowered and playful women. Why this is such an extraordinary event, I believe, is because it's run by artists as opposed to business people. Teesha and Tracy are patient and generous with the participants, helping them find the teachers, classes, and housing that gives them the best experience.

"Since joining this faculty, my classes are always taught down in a small building that used to house fire engines. It is not insulated and sits right on the beach. The view of the sound more than makes up for any discomfort. My medium is different than most of those offered at the retreat, so I am especially awed by women willing to take on such a different art experience. I have watched the letters come in from women all over the world with great things to say about Artfest, and I can honestly say it is all well-deserved praise."

The buzz today is about Vendors' Night, of course, one of the most-anticipated sales for mixed-media art anywhere. Vendors start setting up their booths in the Pavilion Hall at 4:30PM for the 6:30PM door opening. Most of the vendors are old hands at this and have a clear, methodical order to setting up a really nice display. Unlike me, for instance: When I vended at Artfest, I just put my stuff out on top of the table and tried to keep it from looking jumbled. I was clearly out of my league.

The doors open at 6:30PM, and the next 2½ hours are filled with happy shoppers and happy vendors. Mary Beth Shaw introduces her new line of stencils and is astounded to sell out of every single one in less than two hours. Shoppers buy from their favorite artists and stand in the aisles showing each other what they've scored. Someone buys Katherine England's mosaic pig and carries him around happily the rest of the night, his chubby, tiled body glittering under the lights.

Saturday, March 27

We check out Michael deMeng's workshop, which is always great fun, with tools and noise and people making fabulous art out of bits of rusty stuff and gears and scrap metal. After lunch, we go down to the beach, which is lovely. I've never been to the beach on my previous trips to Artfest; to me, "beach" means hot and sunny, while this beach is cold and drizzly. Surprisingly, I have a great time picking up cool rocks and wishing there were a way to get this fabulous driftwood home: it would be perfect in our backyard as a playground for the cats.

We visit Theo Ellsworth's drawing workshop. It's very quiet—just the opposite of Michael's classroom—but the energy here is amazing, too. Plus DD Wigley, Dale's daughter, is in this class, which means The Fabulous Frendl is leashed outside, with her coat and blanket and packet of treats so admiring passersby can honor her with a piece of kibble. Frendl is a regular at Artfest and is without a doubt one of the most brilliant and intuitive dogs I have ever met. Plus cute!

Tonight is Show and Tell. This is where people set up the work they've created, listing the class and instructor's name. It gives everyone a chance to see what others have done, and it also gives them a chance to check out what teachers are offering so they can start thinking about what workshops they might want to take next year. It's a wonderful time to see fabulous work, but it's a little sad, too: Everyone realizes that it's the last event of this year's Artfest and almost time to say good-bye and head home. People are tired and ready to get home and sleep in their own beds, but nobody wants the experience to end. Bittersweet, indeed. We get to spend a little more time with Lisa, and when we go outside with DD, there's The Fabulous Frendl again. Seeing her is the perfect way to end our Artfest adventure.

Sunday, March 28

I don't make it to breakfast—the last meal at the Fort—because, frankly, I'm wiped out. Lying in bed and drinking coffee is about all I can manage. And, in truth, the final breakfast on Sunday morning at the Fort seems kind of sad to me. Lots of people have already left to catch their flights home, and others are saying tearful good-byes to people they won't get to see again until next year.

We drive back to Seattle and check into the Sheraton downtown, where we relax in luxury and spend the rest of Sunday and all day Monday walking around downtown Seattle, drinking lots of coffee, eating good food, buying shoes (!), and constantly turning to each other and going, "Artfest. Wow."

Once you experience it, you realize what people mean when they say Artfest changed their lives.

Rachel and Will Bowen

"We fell down the rabbit hole of Artfest through a series of delightful events. A friend suggested ATCs would be a neat way for me and my husband, Will, to practice new art techniques. I found a local trading event—their theme for that month's trade? Zettiology. Knowing nothing about Zettiology, we turned to the Internet and learned it was created by Tracy Moore. In exploring Tracy's Web site we found Artfest. I immediately asked Will if he was up for 'Art Camp for Grown-Ups' to celebrate his fortieth. He was intrigued. We picked our classes, collected the supplies, and waited. It was a painful nine-month wait.

"We arrived to a buzz of energy. Just standing in line waiting to check in was exciting. There were so many people, all of them artists! We were aghast at the expanse of talent when people started the frenzy of 'trades'—sharing little bits of themselves, supplies, ATCs, 'zines, charms, trinkets, beaded work—each one lovely! The daylong classes afforded us the time to really work with the materials and ask questions, but more important, to open up. We both felt this amazing wave of belonging wash over us. We knew we had to come back to Artfest every year, regardless of the circumstances. And that was just the first day!

A lot of artists we met said Artfest changed their lives. Well, Artfest changed our marriage! Since coming to Artfest, we both are exploring different materials and techniques with ease. We have converted our basement into a space dedicated to creating art, which we use almost daily. Our communication is better too! Will and I got much more out of Artfest than we ever dreamed."

A Down Home Good Time
Artful Texas!, Salado

WHERE: Holiday Inn Express, Salado, Texas

WHEN: Late April or early May (Friday–Sunday)

WHO RUNS IT: Jeri Aaron

COST: $250-350, if you stay on-site

SIZE: 25 attendees, 21 classes (7 per day for 3 days), 7 instructors

When I first heard of Artful Texas! back in early 2010, it was called "Shady Ladies," and the name almost turned me away. I'm glad I got past it, however, because it was a fun retreat and a really important step toward bringing retreats to a part of the country that just doesn't have very many places to take mixed-media workshops. We've got quilters' gatherings—we've got the International Quilt Festival every year in Houston, for crying out loud—but until this year with Adorn Me!, we haven't had major retreats or even any medium-sized ones. So you can imagine how excited I was to find a retreat right in my own backyard. Which is, of course, relative—Texas is a big place.

Friday, April 23

After the long trips of the last couple months, it's so nice to head out on a road trip that lasts only a couple hours. Well, OK, almost six hours. This is Texas, after all, and even a trip that takes you less than halfway across the state can cover three hundred miles. Still, it's nice to be able to leave in the morning and arrive in the afternoon, driving through the Hill Country and its fields of bluebonnets.

Finding ways to support local art retreats is just one of the reasons we wanted to come to this brand-new retreat in Salado, a town neither of us had ever even heard of before. And what's up with that? Earl's lived in Texas all his life and traveled to little bitty towns all over the state for football and basketball, softball and track—but never to Salado. We had no

idea what we'd missed; it's a lovely little town founded in 1859 on the banks of the Salado Creek and known as "The Best Art Town in Texas."

Although large national art retreats are wonderful things indeed, small local retreats are really important. Not everyone has the time or money or spirit of adventure to head off to a big retreat, and not everyone relishes the idea of being surrounded by hundreds of strangers. This is why I searched for a small local art retreat, something that would be manageable for almost anyone if only these existed in every state. That's the idea: I want there to be retreats that are accessible to everyone, everywhere.

Back in the Studio

When you're setting up a retreat, no matter whether it's you and two friends or something significantly larger, think about the name. Jeri changed the name of her retreat after the first year, realizing that with a name like "Shady Ladies," it might make men feel they weren't welcome, which they are.

What is your retreat about? Whom do you want to attend? If you're advertising, think about how the name will resonate with potential attendees. If you have a retreat that focuses on collage, "Snip-n-Paste Weekend" is going to get a different response than "Creative Collage Workshops" will. It all depends on your intended audience.

67

We arrive at the Holiday Inn Express in Salado late in the afternoon, just as a thunderstorm begins to build. While I check in, Earl grabs his camera and takes photographs of the clouds. Up in our room, we find a fabulous welcome basket that Jeri has left for us, thoughtfully filled with nuts, dried banana chips, and fruit—all foods near and dear to the vegetarian heart.

Because there are only seven instructors, the "meet the teachers" is a meeting, rather than an event. We gather in a small meeting room with wine and cheese, cold shrimp, and fruit and get to know each other. Kari McKnight-Holbrook has come down from Ohio, but most of the rest of us are "local," meaning from somewhere in Texas.

When the meeting ends, we find that while we were sitting in the little room without windows, there's been a storm. Earl and I had thought we'd walk along the service road into Salado, just to look around and find something to eat, but it's dark, and passing cars splash water from the puddles along the road. We quickly decide to postpone any sightseeing until tomorrow and make a perfect meal from the treats in our gift basket.

Kari McKnight-Holbrook

"I really have a special place in my heart for both Texas and the Shady Ladies Art Workshops. I've attended most of the big art venues over the years and just really loved Shady Ladies. I felt so lucky to be among those who enjoyed this unique and intimate venue. I really enjoyed all the special little touches Jeri did to make it feel so personal: a handmade journal for each attendee, special dinners, and spacious rooms.

"In these days of huge art workshop venues, which sometimes can feel a bit impersonal, I loved it at the Barbecue Dinner when I saw all the attendees socializing with each other. No individual was left sitting alone; they were invited to join in and sit and chat with others! Artists didn't just stay within their groups of friends they came with; they really branched out and met others.

"As an instructor, I found my students to be so open and wonderfully receptive to experimenting and learning. In turn, I learned from them. I came home fully recharged and ready to go full steam ahead creating new classes. I have made it one of my highest priorities to attend the next one (now named Artful Texas!)."

Saturday, April 24

Today we go to Deryn Mentock's "Wrapped-in-Silk Bangle Bracelet" workshop in one of the meeting rooms located throughout the Holiday Inn. I like having all the rooms in one place; it makes it easy to find everyone and check out what's going on in other workshops. Deryn's workshop is full, with all the places at the table filled with women of varying ages and skill levels. Some are new to jewelry-making, and some have done this kind of work before. It's a nice mix, and the energy is really good.

Why Local Art Retreats Are Important

It isn't just that they're good for local economies or that they're good for people who want to save the money they'd have to spend to attend one of the big retreats. Smaller local art retreats are an excellent way for you to dip your toes into the water and find out if the art retreat experience is one you'll enjoy. And, even better, it's a great way for you to get involved. If you've got ideas about what would constitute The Perfect Retreat, either get involved with one nearby—organizers can almost always use an extra pair of hands—or start your own. Small retreats aren't a replacement for the excitement of a big retreat; they're a great complement. While there are only about half a dozen major retreats a year, you could, theoretically, find a small retreat almost any month of the year. And if not? Get together with some friends and organize your own.

Wrapped-in-Silk Bangle Bracelet

with Deryn Mentock

Deryn's silk-wrapped bracelet is the perfect project if you have some special bits and pieces of jewelry and fibers that you've been saving. Deryn says, "You can be really creative with your focal bead and your beads and your dangles. There are lots of possibilities with the focals. You can use hardware only, you can use vintage buckles—any number of found objects or jewelry findings." She adds, "Warning! These bangles are addicting to make!"

Class Supply List

14-gauge sterling round, dead soft wire, 24" (61cm)

24-gauge sterling round, dead soft wire (for wrapping around the fabric), 72" (18m)

18- or 20-gauge sterling round, dead soft wire, 24" (61cm)

plastic trays for liver of sulfur solution and rinse water

liver of sulfur

rubber gloves

paper towels

measuring tape or ruler

flush cutters for wire

chain nose jewelry pliers

extra-long round-nose pliers (riogrande.com)

small round-nose jewelry pliers

medium Wrap n' Tap or bailing pliers

small chasing hammer, ball-peen on one side

small rubber dead blow hammer or rawhide mallet

steel bench block

bench pillow (or hand towel) for use under bench block

hand drill

vise

steel wool, 0000

butane torch

silk

large beads with holes to fit 14-gauge wire

fibers, tatting, vintage lace, etc.

small beads, pearls, crystals, charms, medals, buttons, etc., for wrapping and for dangles

seed beads

vintage buckle or found item for focal (optional, if you want to make a three-segment bracelet)

bracelet mandrel or baseball bat (optional)

The Right Tools

While it is possible to make jewelry using a limited selection of tools, it is much better to have exactly the tools you need. You don't have to get the Cadillac of tools, but invest in the best you can afford. If you're just starting out and aren't sure what you may want to pursue, think about borrowing or sharing tools to get a feel for what you'll need. Deryn says, "The right tools are important. The better quality your tools, the easier it will be for you to work with them. At first, you don't have to spend a lot of money; but, eventually, get the best quality you can afford."

1 Mix up liver of sulphur solution in a plastic tray, using warm water and a couple chunks of the liver of sulfur. In the second tray, you'll have plain water for rinsing. Deryn has everyone go outside in the parking lot to do this, because liver of sulfur is really smelly stuff.

Note

Do not pour the leftover liver of sulphur down the sink until it's neutralized. This will occur naturally with exposure to air and water, but you can speed up the process with baking soda. Make sure to flush the drain with running water afterward. Alternately, neutralize it with baking soda and pour it onto sawdust or kitty litter and let it dry outdoors before disposing of it in the garbage.

2 Wearing gloves, dip all wire in a liver of sulfur bath to patina. When it reaches the color you want, rinse it in clear water and dry with paper towels.

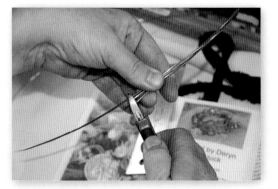

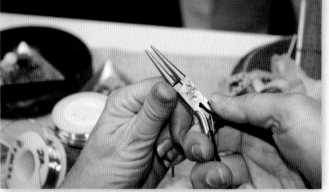

3 Determine what length your bracelet needs to be and cut two lengths of 14-gauge wire accordingly. Include enough extra length (2" [5cm] or so) to make a loop at each end.

4 Using round-nose pliers, create a loop in one end of each length. To do this, start with the end of the wire between the jaws of the widest part of the pliers and bend it around the pliers. Then bend the loop back slightly so it's centered over the remaining length of the wire.

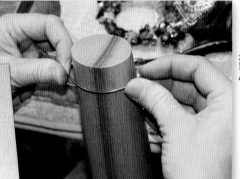

5 Form each segment around a bracelet mandrel (or your baseball bat) to curve into shape.

Note

When using sterling, copper, or other soft metals, it's necessary to harden the wire after forming it to help it hold its shape. A dead blow hammer and a rawhide mallet will perform the same function: hardening the metal without marring it. Tapping metal with the mallet forces the molecules closer together, hardening the metal and making it sturdier. Chasing hammers and other metal hammers are used to form, shape, and texture, a process that will harden the metal but will also mar or flatten it.

6 Harden the wire by tapping it with a rawhide mallet or dead blow hammer on a bench block. Thread large-holed beads onto the wire.

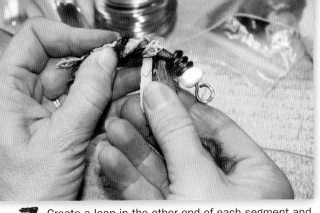

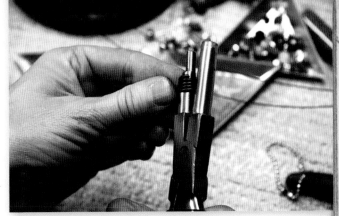

7 Create a loop in the other end of each segment and hammer the loop ends to flatten. Clean the wire up a bit with steel wool. While you have the steel wool out, lightly clean a length (12" [30cm] or so) of 24-gauge wire by pulling it through the steel wool a few times.

Wrap small lengths of fabric and/or fibers around each 14-gauge bracelet segment, spacing the large-holed beads as desired. Over-wrap the fabric with the cleaned 24-gauge wire, adding seed beads and other beads as desired to the wire as you wrap.

Note: Deryn recommends using an alligator clip to hold the end of the fabric as you're wrapping it and says to make sure the ends of the wrapping wire are turned under and tucked into the fibers so the wire doesn't scratch you or catch on your clothes.

8 Make at least two regular or twisted wire jump rings. Plain rings should be made from 14-gauge wire. Wrap an 8" (20cm) or so length of wire several times around either bailing pliers or Wrap n' Tap pliers, forming the loops side by side to make a spring.

Note: Instead of bailing pliers, anything with a uniform roundness—not tapered—can be used as a jump ring mandrel: metal knitting needles, plastic pen barrel, etc.

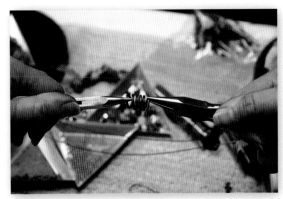

9 Remove the spring from the pliers and separate the loops slightly by pulling on each end with chain-nose pliers.

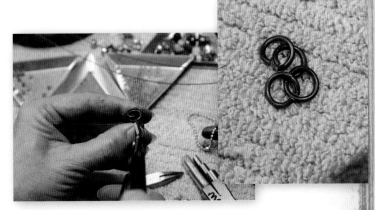

10 Cut the jump rings apart using flush-cut pliers, making sure each cut is flush and not pointed. Flatten the rings lightly by tapping gently with the chasing hammer.

Optional: Twisted Jump Rings

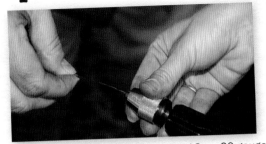

1 To make twisted jump rings, use 18- or 20-gauge wire. Cut two 24" (61cm) or so lengths of wire and insert one pair of ends into the jaws of a hand drill.

2 Grasp the other pair of ends with a vise attached to the bench or table. While you can use either a hand drill or an electric drill for this, Deryn prefers doing it manually, saying, "It's just easier to do with my hand drill, and it doesn't take very long." Crank the hand drill to twist the wires together. They should be nice and tight, but not overly tight. Then form the twisted wire into a coil, as in step 8 on page 73.

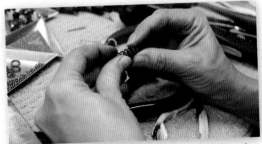

3 Pull the spring coil apart slightly and then cut into individual rings using flush-cutters.

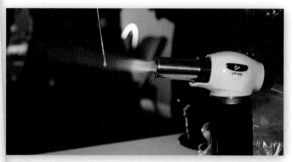

11 Clean the rings with steel wool. Open the jump rings by twisting them slightly with two pairs of pliers.

Attach the two bracelet segments together using both jump rings at the join. Close the jump rings by holding each end in a separate pair of pliers and grinding the ends together, back and forth, until they're snug.

12 To make a clasp, start with a length of 18-gauge wire about 3" (8cm). Ball one end of the wire using a torch: Use pliers to grasp one end of the wire and hold the other end in the hottest part of the torch flame—the bright blue part—until the end melts and shrinks up into a little ball. Cool the wire by dunking it into a pan of water.

Deryn recommends putting a pan of water under the wire as you heat it, just in case the ball falls off. If it falls into the water, it will cool immediately. If it falls onto your table, however, it's going to burn a nice little ball-sized hole.

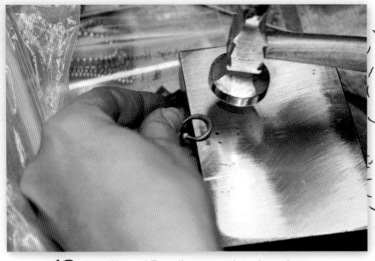

13 Use Wrap n' Tap pliers to make a large loop on the balled end. Hammer the other end to form a paddle. Use the extra-long round-nose pliers to make a slightly smaller loop at the paddle end.

Note

Add as many charms as you feel your bracelet needs. Create them by forming a simple wrapped loop, just as you wrapped the bracelet itself. Attach charms to the bracelet at jump rings and the clasp end, and then close the loop and wrap excess wire around the base of the loop. (Make sure to attach each charm before closing the loop.) Trim excess wire using flush-cutters. Clean the wire of each charm with steel wool after wrapping.

14 Flatten both ends of the clasp with a hammer and bend the balled end slightly back, using pliers. Clean with steel wool. Harden the clasp by tapping it with a rawhide mallet or dead blow hammer.

You don't want to skip the hardening part on the clasp because it needs to be sturdy enough to hold its shape and hold the bracelet on without stretching out.

Attach the clasp to the bracelet at one join by opening and closing the small looped end of the clasp as you would a jump ring. The clasp will then hook to the other join on the bracelet.

At lunchtime, we hurry down to watch Peggy McLarnan of Salado Flame Works and Studio Salado do a free glass demo. Her torch is set up by the pool and she is making some really spectacular glass marbles.

Then we drive into Salado for a book signing at Stamp Salado, the little rubber stamp store on Main Street owned and operated by Sandy Shaw. The shop is in an old house, so it has those wonderful little rooms and nooks and crannies, all filled with stamps and stamping and scrapbooking supplies.

Mark Jetton, owner of Deadbeat Designs Rubber Stamps, comes by to say hello. I met Mark years and years ago when I went to Houston to teach at Iconography, where he worked before starting his own rubber stamp company and moving to Salado. Although Mark surely has a bunch of other things he could do on a lovely Saturday afternoon, he agrees to wander through downtown Salado with us and ends up giving us a fabulous tour. One thing I've discovered is that the very best way to learn about any town is to be taken on a walking tour of it by someone who really likes it a lot. Mark knows the history and the art community and where all the galleries are located.

We might still be there wandering through downtown Salado, in fact, if I hadn't realized it was time to head back to the hotel for the barbecue.

The barbecue—good ol' Texas barbecue, complete with beans and potato salad and, for the vegetarians, grilled portobello mushrooms—is out by the pool, which is a lovely place to gather as the sun sets. We sit around the tables and get to know each other, talking about where we're from and what workshops everyone's taking.

Sharing Food and Thoughts

Sharing a meal is a good way to spend some time sharing ideas, so it's a great addition to a retreat. Whether it's a brunch before a workshop or a wine-and-cheese feast at the end of the day, you can sit down and talk about what's inspiring you and making your brain buzz. If you've got a large-ish group, you might think about ordering in or having someone cater a meal. If you have a group that's also interested in cooking, think about an Art and Food Weekend, where you take turns experimenting in the studio and in the kitchen.

Choosing Workshops

Don't rely exclusively on the photos provided on the retreat's Web site. While the class description and the photos will let you know what you're going to create in that particular workshop, you might want to know what else that artist makes or what experience she has in other media. Finding out that they've been doing this for twenty-five years lets you know that this is someone who probably has lots of tips and advice to share, or finding out that this technique is something that the instructor has just developed tells you that you're probably not going to get a chance to learn it anywhere else any time soon. Do a little research before you sign up.

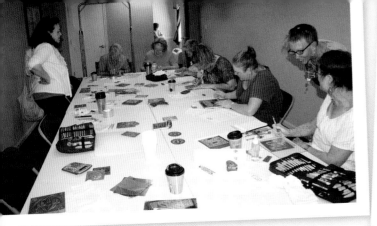

After dinner, we head inside to the large meeting room on the lobby level where tables have been set up around the edge of the room for vendors and demonstrators, and in the middle of the room for people who want to sit and rest or visit or work on their own projects. Jeri has arranged for a series of door prizes to be given away throughout the 7:30–10:30PM event. She's given me space at a table by the door where I set up for another book signing, which is lots of fun, with plenty of visiting.

Vending Your Way

If you're hosting your own mini-retreat, you might want to arrange a Vendors' Night to give everyone a chance to shop. It might help to agree in advance on a price range so nobody is surprised at how much everyone else is asking for their work. Discuss how you'll handle trades—who wants to trade, who would rather not. While trades between artists are a staple at the larger retreats—it's how many artists add to their personal collections—it's not something everyone wants to do. Decide on the guidelines and then show each other your work. You can combine a show-and-tell with vending if that appeals to your group.

Sunday, April 25

On Sunday morning, we check out Magdalena Muldoon's Traditional Metal Embossing workshop, where they're creating a metal light switch plate. It's another one of those classes where you smack yourself in the head and go, "Why didn't *I* sign up for this?" Even if I didn't love the look of embossed metal, which I do, I'm a total sucker for little bitty tools, and, man, does she have some cool tools!

We have to check out at noon, and we've arranged to spend the afternoon in Austin with our friend Wendy Hale Davis. There's an annual downtown art festival, so we head down there to see what's going on and say hello to some of our favorite artists on the art fair circuit. We'll spend the night and head home on Monday—a nice, leisurely trip compared to the others, something we really need as we prepare for our next huge trip in May.

Make it an Art Adventure

If you're lucky enough to be able to drive to a local retreat, check out some of the things you can see along the way. Check for local art fairs, gallery openings, museum exhibits. If you're going to be driving through a town anyway, it's fun to make it an art-filled journey. And you just might pick up an idea or two that will make its way into your workshops.

Into the Rabbit Hole
Art & Soul, Hampton

WHERE: Embassy Suites, Hampton, Virginia

WHEN: Late May (Wednesday–Sunday)

WHO RUNS IT: Glenny Densem-Moir

COST: $140 per class. Lodging and meals are not included, but attendees get a special rate if they stay in rooms reserved for the event.

SIZE: 475+ attendees, 85+ classes, 35 instructors

We went to Art & Soul in Portland back in 2007, and then we went to Art & Soul in Las Vegas this February. So of course we had to come here to experience the full spectrum. Art & Soul, Portland, is very cool— Portland is a wonderful place to visit. The shuttle there will take you downtown, so there's a chance to get out and walk around and see lots of fun shops and places to get coffee. In Hampton, there's the beach— ocean—water. For those of us who love few things more than standing in the sand and looking out over the water and imagining what's on the other side, it's hard to beat the coast. While the Embassy Suites isn't on the water, it's not too far away. Ideally, you'd get to go to all of the Art & Soul retreats, but who really gets to do that (besides Dale Wigley)? So pick the one you want to go to, the one you can afford, and the one that offers something fabulous for you. Casinos? Funky downtown? A walk on the beach? It's up to you.

Wednesday, May 19

We arrive in Hampton, just a little road-weary from our drive halfway across the continent, in time to check in lickety-split and find the ballroom where the Alice in Wonderland Costume Contest is taking place. The costumes are fabulously inspired with hats and aprons and makeup, and everyone's excited about their trades and hunting up friends from last year. Or from Vegas. Or Portland.

Location, Location, Location

For some of us, the heat at Art Unraveled in Phoenix in August is absolute perfection. If you absolutely, positively loathe heat, the chilly ocean air of Port Townsend in early spring is probably more to your taste. It's something to think about because for many of us, where we are affects what we do. We have a lot more ideas and energy if we're not physically miserable.

If you're setting up a small, local retreat, think about what would make you most comfortable and productive: Would you love to take a *plein air* painting class on the grounds of your local museum? Or does being outdoors make you itch? Maybe they have classroom spaces where you could set up workshops. Think about resorts in the off-season, local parks, universities during the summer when some of the classrooms are empty. There are all kinds of places that might work for you, whether it's just you and a couple of friends or a larger local group. If one of your friends just happens to have a beach house or a cabin in the mountains, well: everyone is in luck!

Packing Supplies

My best advice: plan ahead and then ship ahead. If you're taking a wide variety of workshops that require everything from a soldering iron to alcohol inks to a heat gun, your best bet is to buy it, pack it, and ship it. In almost every case, arrangements have been made with the host venue to receive boxes ahead of time. Not *way* ahead of time—they won't hold stuff for weeks—but a day or two before workshops begin. Many supplies may not be allowed in carry-on or checked luggage, so research what's allowed ahead of time if you must take your supplies with you.

Here, seasoned workshop attendees have some sound advice for packing your supplies.

- Make sure the lids on jars and bottles fit and are tight, and then tape them securely, just the way bottles of paint come when you order them.

- Double-bag everything that might leak or explode. The changes in pressure on the plane can cause this, and you don't want one bottle of black ink to ruin everything in your suitcase.

- Label everything. If someone's going through your suitcase, you don't want them wondering what those odd tools are. And you don't want them to wonder why you're carrying them, either. Explain everything in a friendly note attached to a copy of your workshop supply list.

- Keep all of this separate from your clothes. If something leaks or spills or is confiscated, you're still going to need clean underwear.

Thursday, May 20

While Earl is out taking photographs, I hang out in the office/store with Glenny and Emily (Glenny's assistant) and watch all the excited attendees coming in for information and supplies and just to say hi. In the afternoon I go with Earl to find out what Michael deMeng is doing that's making all the noise—hammering! power tools! So you know we have to check it out. "Cave of Pages" is not only a cool project; it's also a chance to try out a lot of different stuff—cutting and drilling and sanding and painting. It's one of those classes that proves that there's something at art retreats for everyone.

In the evening after class, lots of people—students, teachers, vendors, staff—hang out in the lobby. Embassy Suites are known (and loved) for their Manager's Reception every evening. Free drinks, free nutrition-less snacks (because that's the kind you want, right?), great conversation. It's fabulous. The best part is that people bring their projects and their art journals and what they've bought in the store. We go from group to group—teachers clustered over here, decompressing and catching up on what everyone's been doing since Las Vegas, Glenny and her crew trying to unwind from a really busy day—visiting and making dinner plans. We go with Glenny and Maria and their helpers to the hotel restaurant, where we have dinner and then sit for hours, talking and laughing until the staff, in a really broad hint, begins vacuuming under nearby tables. We take the hint and call it a night.

Guy Classes

Of course there aren't any classes that are "guy classes" or "chick classes." But there are people who think there are, and there are people who think there's nothing at art retreats for Manly Men. Or Women Who Love Tools. You read what Michael McMillen had to say (see page 17), and Art & Soul Hampton proves it again: no matter what catches your interest, you can find a workshop that's perfect for you. Here in Virginia there are workshops with soldering, electroforming, etching, mold making, enameling, glass casting, and metal sawing. And that's not an exhaustive list; that's in addition to the workshops you might likely expect, like journaling and watercolor and collage. Don't ever let anyone try to convince you art retreats are too girly.

82

Friday, May 21

Today I get out and walk around and try to get a feel for Hampton, Virginia. It turns out it's not really a walking kind of a place, at least not where the hotel is located. Although we can easily walk to a Wal-Mart, for example, there's nothing cool or funky, at least not that I found. Still, you can get a ride to the beach, and that counts for a lot.

Saturday, May 22

The excitement today is watching people set up for Vendors' Night. Because I'm working, they let me hang around and watch—it's generally off-limits until everyone gets their stuff up and ready, which makes sense. It's impossible to set up your booth and unpack if people are trying to shop and are asking you a bunch of questions and wanting you to "put things back" or "start a stack" for them.

- **LIGHTING:** Will electricity be provided? Often it's not. There are often not any electrical outlets available, so don't plan elaborate lighting until you know you'll have a place to plug it in.

- **DECOR:** Whatever you use to make your booth or table more attractive needs to 1) enhance the work you're selling, rather than overwhelm or detract from it and 2) be light and easily portable. For tables at art retreats, many artists rely on the cardboard boxes they use to pack their art: when these are empty, they arrange them on the table and drape them with a nice—often black—cloth, creating a multilevel display area.

- **ACCESSIBILITY:** Think about how you'll arrange your space. You want a lot of pieces so people will have choices, but you don't want it so tightly packed that people can't reach in and pick up pieces they want to look at. If you have a booth, you don't want it so full that people can't get inside. Think about shoppers with disabilities and try to make space for people to maneuver.

- **SECURITY:** While it would be nice to believe that everyone who attends art retreats is a veritable Girl Scout, honest and true, we know that's not always the case. Make sure your cash box or money bag is behind the table, out of sight. If you have expensive jewelry or other small valuable pieces, think about how you'll keep those from wandering off. A display case, perhaps? Necklaces and bracelets can be pinned to velvet boards. It's a good idea to have a friend or assistant to help keep an eye on things and help with sales so you can relax and talk to your visitors.

Setting Up Your Table

If you're going to vend at an event, the first thing to do is apply. It's not just a matter of showing up with your stuff; for the larger retreats, there's a lot of competition to have a table and not that many tables to go around. Organizers want a variety of top-quality work, so if you're new and unknown, you may be asked to submit photos or slides of what you're going to sell.

Once you're accepted, you'll want to think about how you'll set up your space to make it as attractive as possible. Find out how much room you'll have (often it's a 6-foot table; sometimes you may get half that; sometimes twice that). Then consider the following.

Sunday, May 23

This was my favorite day so far. We spent the day as usual, wandering around checking out workshops and taking photographs and little videos. Then we stopped in Ty and Marcia Shultz's "Big Birdz" class, and oh, my! The pieces people were creating were just amazing—big birds, indeed: 3-foot tall bird sculptures made of fabric and Paverpol—the glue-like stuff they introduced in their workshop in Las Vegas, remember?—that, when dry, can be painted and sealed and left outdoors. Ty figured out how to construct these Birdz so they can be disassembled for travel and then reassembled at home, and the excitement in this class is a thing of joy. And the mess! It's always great to be in a class where people are making a mess and loving every minute of it.

I get some video of Ty talking about the Birdz and about some new ideas he's working on. I love Ty, who gets all excited talking about ideas and possibilities—he almost vibrates, and I love how he's figured out a way to do stuff he loves and share that with other people, who discover that they love it, too.

The evening is just as fun. We're hanging out in the lobby, of course, having a glass of wine. And somehow this thing happens, this thing that I've been dreaming about forever and wondering how to create. But you can't make it happen—you can just hope you'll be there when it does, all on its own. People start showing up and pulling up chairs—Carla Sonheim, Melanie Testa, Stephanie Lee, Jill Berry, Diana Trout. Someone takes out her journal, and then everyone's opening up their bags and pulling out journals and projects and passing them around. We talk about techniques and what classes everyone's teaching and taking, and then we talk about books and magazines and editors: Many of these people are working on books and articles, and we compare experiences and talk about who's easy to work with and who's kind of not, and it's amazing.

Ty and Marcia Shultz

"We debuted our 'Big Birdz Class' at Art & Soul in Hampton, Virginia—a sculpture class where a handful of bright and talented students brought their large creations to life while challenging the limits of a one-day class. We were amazed as they 'flew outside the box' and through the hotel manager's reception. Art & Soul provides an opportunity to harmonize with hundreds of artistic spirits to create, learn and share."

Trades

You hear a lot about trades at art retreats. People start talking online about making trades months before the actual retreat, and you wonder what on earth they're talking about. Trades can, in fact, be pretty much anything. Basically, a trade is something you—duh—trade with others. They're more popular at some retreats than at others, but it never hurts to have a supply on hand for when you want to meet someone.

Trades can be ATCs you've made or badges you've created. They can be a bag with some candy made in your hometown or a packet of fibers from your stash. If you have boxes and boxes of fabulous buttons and trims that you've realized you probably aren't going to use, you can make up little bags of those to trade. Think of the possibilities: bookmarks or small cards with prints of your work, keychains with beads from your stash, packets with scraps of your handmade paper. It's up to you; the only thing you really must have in your trade is your contact info—at the very least, your name and e-mail address or phone number so someone can get in touch later on. Lots of people use Moo cards (moo.com) or business cards attached to something they've made—a handful of dyed fibers, a mini bezel, some collage fodder in a tiny bag.

Trades are the perfect introduction to almost anyone at art retreats. The etiquette is to ask, "Are you trading?" If yes, then you ask if they'd like to trade. If they say no, lots of people will offer a trade anyway—it's a really warm and fuzzy thing to do.

This is the kind of experience you never get to have in regular life, where you're probably the only one in your community who does what you do. So getting to sit down and talk about the experience with other people who do the same thing is a fabulous opportunity to network. We pass around Moo cards and make notes about who needs a contact where and with whom. It's the kind of social experience that sparks all kinds of ideas and projects, and it's just marvelous. Other people stop in and join us, and the circle grows wider and wider—and there's the perfect metaphor for what can happen at an art retreat.

86

Fatbooks

Also called "chubby books," these are collaborative books created ahead of the actual retreat, with information supplied and coordinated through the retreat's Yahoo Group. Participants create an assigned number of pages on that year's theme and send them to the coordinator, who assembles the books and brings them to the retreat to hand out to participants. This is an excellent way to get involved, meet new people—the on-site exchange is often a party in itself—see other people's work, and learn new techniques. Preparing the pages and thinking about the theme gets you even more excited about the retreat than you were already, if that's possible. Check the online group to see if they have a fatbook swap; if not, you might want to be involved in getting something started.

POCKET SKIRT FAT BOOK

Monday, May 24

There are still classes going on today, but our time is up, and we've got miles to go before we sleep. We haven't been to the beach yet, so that's our first stop. Then we head up through historic Williamsburg, which leaves me underwhelmed. After a fabulous art retreat, it's hard to find anything else that can compare, you know? We realize how lucky we are that our adventure isn't over: our next stop is Valley Ridge Art Studio in Wisconsin, so the post-retreat let-down is minimal for us. We've got ten days to get there and a lot to see on the way, with three book signings and an artists' date in Lawrence, Kansas, so we'd better get on the road again—oooh, is that Willie Nelson I hear?

Getting the Star Treatment
Valley Ridge Art Studio, Muscoda

WHERE: Valley Ridge Art Studio, Muscoda, Wisconsin

WHEN: Various April through October classes, typically two to three days each

WHO RUNS IT: Katherine Engen

COST: $147.50 per day, average. Lunch and lodging are arranged separately.

SIZE: Max 15 students per workshop

For years, I've heard people talk about Valley Ridge Art Studio in the same tones rubber stampers used to talk about Stampa Barbara, the ultimate stamp store in Santa Barbara, owned by Gary Dorothy and the dream destination for stampers the world over. Because artists talk about Valley Ridge that way, I'd always wondered what it was that made it so special. So, naturally, I decided to go find out. And, oh, my! I was not disappointed.

Thursday, June 3

Omigod, this is a fabulous place. I'd heard it was, but you know how that goes: People rave about things and tell you how perfect they are, and then you get there and look around and go, "Eh." It's happened to all of us at some point, and after a while, you listen to the raving and think, "Yeah, yeah, yeah." So when we drove the convoluted route here, turning about a million times and having to backtrack (but only once—yay, me! Yay, iPhone!), I wasn't expecting a whole lot, right? A house, a barn, a classroom. Some grass. Maybe some cows—it's Wisconsin, after all.

It's a Full-Time Job

Organizing a big retreat isn't for the faint of heart. It's always best to start small. Really small. Katherine explains that even smaller workshops take up every minute of every day: "During our workshop season, I spend seven days a week working. When a workshop is in session, I work from 6:30AM until 10:30PM. It isn't unusual for me to continue to work until 1 or 2AM, keeping up with the next two workshops as one is taking place. During the off-season, I have a bit more free time and do take a few vacations; however, my computer goes with me everywhere. We start our registration process for the following season in December, updating our Web site, creating brochures, marketing, etc."

Imagine my surprise. You drive all those miles, passing Amish buggies that could be from 1950 or 1850. You pass trees and cross the Wisconsin River, and then you turn down Wytek Road and curve around and come to the small sign that announces "Valley Ridge Art Studio." You turn in, and there before you appears Eden: rolling grass and a garden of peonies, immaculate buildings—the Farmhouse, the workshop, the class-room, the community room, Katherine's house—and beyond that, the land—hills and trees and the river. The workshop season runs from April to October. They've tried having workshops during the winter months, but the students they attract are mostly women who have no desire to spend winter weekends in a location that may or may not be bombarded by a blizzard halfway through their weekend retreat. So now they stick to the warmer months.

Students at Valley Ridge have the option of staying off-site at one of the area bed-and-breakfast houses, or they can stay on-site in the 1856 red Farmhouse that's just steps from the classroom. Our room is in the downstairs room that was originally a living room. It has a bathroom down the hall, and upstairs are three more bedrooms and another bathroom. There's a living room, dining room, and a full kitchen with windows all around, a huge screened-in porch off the kitchen, and a spacious deck beyond that. I want to move in perma-nently, and I haven't even seen the rest of Valley Ridge yet. We get settled in and then go down to Katherine's house for dinner with Daniel Essig, this weekend's instructor. We feast on grilled salmon, fresh asparagus, and a salad, perfectly paired with white wine and good conversation. We sleep with the window open and the sound of coyotes howling in the distance and cows mooing quietly throughout the night.

90

Jessica Poor

"Soon after moving to Milwaukee to start grad school, I began hearing stories about the fabulous workshops at Valley Ridge Art Studio. One day a friend of mine called and asked if I would like to take her place at a workshop there, her treat. She was unable to go, and so she generously gave me her spot. Judy Wise was teaching a two-day seminar on encaustic painting and collage. I had such an incredible experience. I was hooked. The setting was beautiful, Kathy Engen, the proprietor, was so open, generous, and kind that I felt instantly at ease with her. I had a really great time. Met some fantastic women. I made a bunch of cool work, and I came home and taught my friend how to do it too! After having this one great experience, I knew I would be back!

"I next visited Valley Ridge just after my twenty-five-year relationship ended badly. I was very sad and a bit dazed, but when I saw the title of the class, I knew it would help me get through some of the pain I was feeling. The class was Extreme Personal Journaling with Juliana Coles. What a dynamo she is! I learned so much from her, not just in art techniques, but the class helped me to voice the pain I was in while building goals and dreams for what my future might look like. I keep that journal next to my bed, and if I start to feel down or directionless, I read through it again. I use the techniques she taught me all the time, and I really value the experience I had at that workshop. I would even go so far as to say it was cathartic.

"By the time December rolled around, I had saved enough to buy myself the best Christmas present ever—three workshops at Valley Ridge! I am a bookmaker at heart, so making books with Daniel Essig was fantastic! Sadly, one of the classes I signed up for was canceled. I thought about getting a refund, but then I thought, 'I'm going to pay it forward like my friend did for me!' So I called Kathy Engen and transferred the class and lunches to a new friend of mine, and so we both got to meet and make art with the lovely Michael deMeng.

"Every time I go to Valley Ridge, I am so invigorated and excited to see what will happen next. I meet great people, and we share, sometimes intimately, while we create new work and acquire new skills."

Friday, June 4

I wake up before 6AM, without an alarm, because my brain apparently remembers that sometime between 5:45 and 6AM, the first bird will wake up and start waking up all the other birds—robins, bluebirds, cardinals, red-winged blackbirds, swallows. Sure enough: The songs start slowly, but soon you can hear more and more birds joining in. I wish I could identify them by song. Isn't there an iPhone app for that?

Katherine thought of everything when she designed the classroom, from the huge windows to the big tables arranged in a U shape—the instructor's area at the front in the middle—so everyone has an unobstructed view. There's plenty of room to spread out. When students arrive, there's coffee going, with a row of ceramic coffee mugs, a sugar bowl and creamer, a bowl of fruit, and a jar of candy—no foam cups, no sense of hurry and rush. You feel, simply, taken care of, as if someone has arranged everything to make your experience as nearly perfect as it can be.

Exactly! Katherine says, "I had attended some art retreats, and although I enjoyed them, I wasn't impressed with the numbers, the sharing a 6-foot table with four other people, crammed into a hotel room that was inadequate to meet the needs of an art event. I also wanted to take and be exposed to more art, so I thought, 'Why not bring them here and create an atmosphere that is conducive to enriching the creative experience?'" Excellent idea, as it turns out.

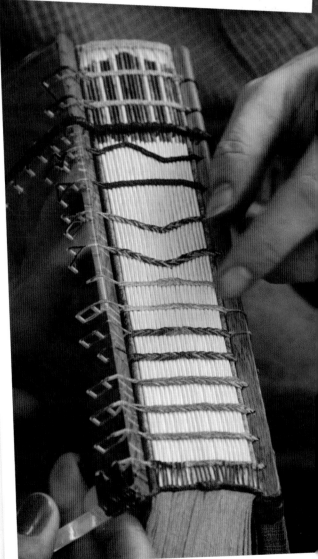

Daniel's workshop begins at 9:30AM. There's no time to waste because this three-day workshop covers a lot of ground, with Daniel teaching every part of the process of making a book except making the paper for the signatures and spinning the threads used to bind the books. The first thing he teaches is the centipede binding, which is a wonderful lesson in itself. Not only is it adaptable to a variety of surfaces and lots of applications—you can create centipedes not only on book covers but on bags and clothes, for example—but he's designed a project that incorporates the centipede: a leather cuff. He teaches the stitch, gets everyone started on the cuff, and then begins the book. Some students are accomplished bookbinders. When they finish one step and are waiting for the next set of instructions, they can work on their cuffs, practicing the stitch and trying variations. For intense workshops like this one, having that little extra project is perfect, keeping people from getting bored and giving them something they can finish and take with them.

At noon there's lunch in the community room, a wonderful gathering place with comfortable tables and chairs, art on the walls, and a full kitchen and bathroom. The bathroom, complete with shower, has both an inside door and an exterior entrance because Valley Ridge also hosts fly fishermen throughout the season. There are some this weekend; their tent is set up next to the building. They have access to the bathroom, but we don't see much of them—they spend pretty much all their time down at the river doing what fishermen do, of course.

Lunch is delicious, with a variety of salads, cheeses, bread, and cold cuts. After the afternoon session, Earl and I get a tour of the 120 acres. If I weren't in love with this place already, this little ride on the four-wheeler through the trees and down to the river and up to the meadow and over to the hidden stream—that would do it. The best part of all? We round a stand of trees and come to a complete stop, a young deer standing in the middle of the path right in front of us. She takes her time and poses for a couple of photos, seeming to know that she's safe here at Valley Ridge. Did I mention magical?

94

Centipede Stitch
with Daniel Essig

Dan's centipedes crawl across the covers of his books, creep along the top edges, and stretch across the spines. The coolest thing about them is that they can embellish not only hand-bound books, but also leather cuffs, shoes, or clothing. For this class, Dan taught the centipede stitching the first day and handed out strips of leather so the students could make cuffs, working on them throughout the workshop when they were caught up and waiting for the next step in their Coptic binding or when they needed a break. They also practiced on the lid of a white cardboard box, which is an excellent surface for creating your first centipedes.

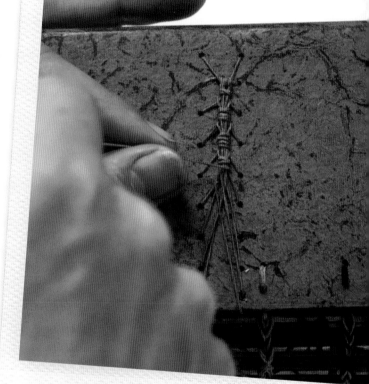

Class Supply List

substrate (for the first centipede, try working on a sturdy piece of smooth cardboard)

awl

pencil (white pencil if your substrate is dark)

4-ply waxed linen bookbinding thread

#3 darning needles (Dan likes English darners, which are less likely to break than cheaper needles), 2

clear plastic ruler (Dan recommends getting one of the thin flexible plastic rulers and poking the holes in it so you can lay it on your surface and mark through the holes rather than measure out the holes each time you make a centipede)

needle-nose pliers

NOTE: If you want to make a centipede on leather, you'll need a leather punch or a 1mm hole punch—an awl won't work as well because you need to remove some leather in the holes. To create a centipede on a wooden book cover, you'll need a drill or drill press.

1 Make 2 vertical rows of holes ½" (13mm) apart. Each of these rows will have 9 holes, ⅜" (10mm) apart. This will create a set of 9 pairs of holes. You can make much longer centipedes later on, but start with 9 pairs of holes.

2 Number the holes on this practice piece: at the top of the rows, label the left one "left" and the right row "right." Then number the pairs of holes from top to bottom, 1 through 9.

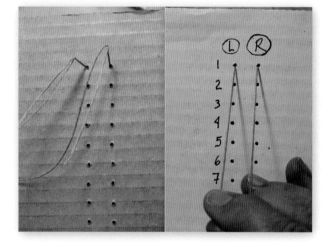

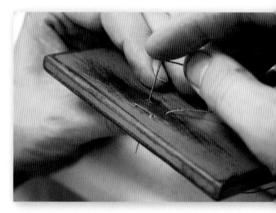

3 Thread a needle onto each end of a 5' (1.5m) length of thread, leaving short tails on each needle. Centering the thread on the back or inside of the cardboard, bring one needle out through the top left hole—left #1—and one out through the top right hole—right #1.

4 Start with the needle coming from left #1, cross over on the front and go into right #2 and then back out of left #2. (This photo shows work on a wood cover instead of the cardboard.)

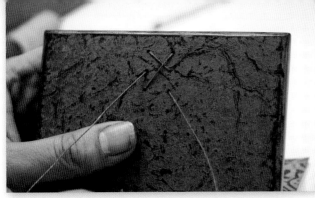

5 Right #1 comes over and goes into left #3 and then comes out of right #3.

Stop and take a look at the back of the cardboard. You should see a ladder being formed, with the thread crossing evenly from the holes on one side to the holes on the other. No threads will cross each other on the back side.

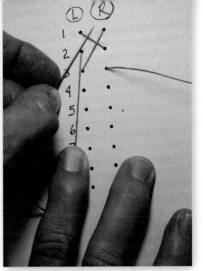

6 Now you're going to begin forming the body. Bring left #2 up under the thread coming out of left #1.

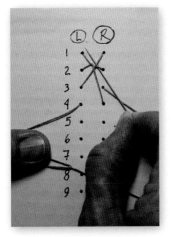

7 Then bring left #2 over the top of that thread as well as the thread crossing between right #1 and left #3. Insert the needle into right #4 and then out of left #4.

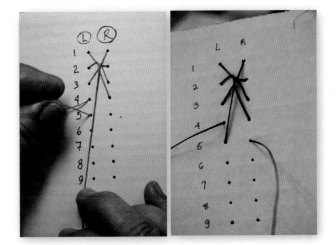

8 Take right #3 and insert the needle under the thread above it, from bottom to top, so it comes through the V at the top. Then go down into left #5 and out of right #5.

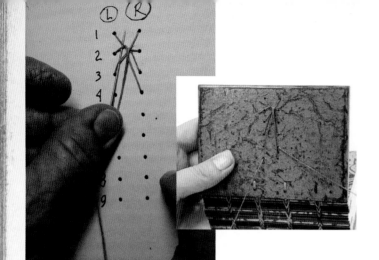

9 Insert the needle from left #4 under the point where all the threads cross, from bottom to top, having the needle come out in the V at the top. Bring the thread down into right #6 and out of left #6.

10 Now you create the head of your centipede. First you have to set the last leg. Come up from right #5 and, again, underneath the section where all the threads cross, inserting the needle from the bottom to the top, coming out at the V. Come over the threads and reinsert the needle through the bottom V, forming a loop that will start the head. Repeat 2–3 more times, creating a coil that runs left to right. Then take the needle over and down and into left #7 and come up through right #7.

11 Bring left #6 up and over the right side and insert the needle between rows 2 and 3, from right to left.

12 Repeat, going from right to left again, creating a wrap around the stitches.

13 Repeat a couple more times, creating a coil that runs vertically and squeezes the stitches tight so your centipede's head pops up.

14 Go in at right #8 and then come out at left #8. Bring right #7 up underneath the threads between 3 and 4, passing from left to right.

15 Make two coils, then go in at left #9 and come out at right #9. From left #8, go up and cross over and make a coil, from right to left, between rows 4 and 5.

16 Make two more coils, one below the other. To finish off this thread, use pliers to insert the needle up through the center of the "body," and then clip the excess thread close to the body (no need for a knot).

Take right #9 and insert the needle under the threads between rows 5 and 6, from left to right, repeating 3 times, and then again use pliers to push/pull the needle up through the center of the body from the bottom up through at least two sections. Clip this thread close to the body as well.

Saturday, June 5

Valley Ridge is different from other art retreats in that it's self-contained, in one place, with one instructor teaching one class at a time. If you're at Valley Ridge, you're there for the class, so that's the place to be. Everyone is there all day long, in a group, and your attention is focused on this one thing. Nobody leaves for one day to go into town shopping (although most of the locals do get up extra early on Saturday and Sunday mornings to hit the yard sales on their drive in) or to wander around or just take a day off. Students who come here take their workshops seriously, and the days are intense.

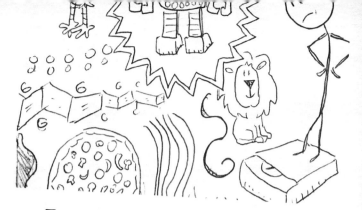

Sunday, June 6

I start the morning out on the deck, sipping fresh coffee and watching the sun rise. You don't realize how noisy and rushed most of our lives are until you're far away from the city, surrounded by huge expanses of quiet, peaceful greenness. Valley Ridge may well be the most beautiful place I've ever stayed.

The last day of Dan's workshop is intense: everyone wants to finish their book before they leave, and sometimes things don't cooperate. Some students work easily, but others have trouble with some of the steps. It's really cool to see how everyone helps each other catch up.

Everyone works steadily, and by the end of the day, the books look fabulous. Earlier in the day, Katherine passed around a sheet for people to fill out if they want to share their contact info so they can stay in touch, and she hands out copies of this at the end of the day as people pack up. This is a really great idea, and it comes in handy later on.

Treat Your Teachers Right

I've talked to a lot of people who teach at mixed-media art retreats, as you might imagine, and they talk about the good, the bad, and the ugly. One thing I heard over and over was that Valley Ridge was hard to beat. Taking a lesson from Katherine, here are some ways to make your instructors want to come back:

- Provide a nice place to stay. At the very least, give them a room of their own and a bathroom they don't have to share with three kids and an aquarium full of garter snakes. Instructors at Valley Ridge have a place to unwind and relax at the end of a day of teaching.

- Feed them. If someone's teaching all day long, they don't have time to figure out what they're going to eat. If you don't cook, have something delivered.

- Pay on time and in the exact amount agreed on in the contract. Don't quibble, and don't renege on agreements. What I heard from instructors about Valley Ridge is that the check is there, on the bedside table. Is it any wonder that *everyone* wants to teach at Valley Ridge?

101

Supply Lists

Katherine isn't alone in stressing the importance of supply lists. While she stocks and sells most if not all of the supplies needed for each workshop, and while other retreats have on-site stores, supplies are still a huge deal. Workshops with long lists of expensive, hard-to-transport supplies just aren't going to do as well as workshops that don't require students to bring everything but the kitchen sink.

Katherine says supply lists are the biggest challenge for her at Valley Ridge: "The most difficult part is getting the message across to the instructors how important it is to pay close attention to their supply lists. [It's frustrating] when you send a copy of the confirmation letter to the instructor and ask her/him to make sure the supply list is correct and they sign off . . . and the workshop takes place and a supply is missing, and the instructor says, 'I had that on my supply list.'"

You hear students complain about supply lists all the time, saying they would have taken a certain class but didn't because the supply list was too long.

Everyone heads out except Dan; Katherine's taking him to the airport tomorrow. We have one last dinner together and sit and visit for hours on the screened deck outside Katherine's bedroom, listening to the owls and coyotes and talking about art and Dan's early experiences caving. Walking back to the farmhouse in total darkness is amazing—you don't get this kind of darkness near a city, and it really does feel like you're far, far away from anyone else anywhere. I'm going to miss Valley Ridge a lot.

Monday, June 7

One last morning drinking coffee on the deck, and then we pack up and head out for a book signing in Manitowoc, over on the other side of the state on the shore of Lake Michigan, and then on to Bead&Button in Milwaukee.

Katherine is gone when we leave, having left early to take Dan to the airport in Madison, but we pass her on the little road heading east, and we pull over and stop and visit for a minute there on the little winding road, making plans to meet again somewhere. Maybe New Orleans in 2011? We're already dreaming

When Emotions Run High

Whether you're a student or a teacher or an organizer, you need to be prepared for the little glitches, the times when things don't go smoothly or someone has a minor melt-down—or a major one. One thing we learned on our adventures was that people come to art retreats from all kinds of situations, and sometimes it's hard to leave that behind, even for a few days. There may be tears, temper tantrums, someone packing up and leaving. At one retreat, a brand-new mother got a little teary, away from her baby for the very first time. As a student, you learn to take deep breaths, maybe step out of the room for a min-ute, maybe take a walk. As an instructor, you put to use your teaching skills, figuring out what's best for each student and using your experience to help them get through the steps that are giving them problems (this is why teaching isn't for everyone). As an organizer, you've got to stay calm and employ your very best People Skills. It's an intense experience, and things will go wrong, but they can be handled if at least one person is a calm oasis. Let it be you.

Bring on the Bling!
Bead&Button Show, Milwaukee

WHERE: Bead&Button Show, Milwaukee, Wisconsin

WHEN: Early June (Sunday–Sunday)

WHO RUNS IT: Kalmbach Publishing Co.

COST: $30 registration, $80–$1,000 for classes (from beginning-level to Master's-level workshops. $500 is average). Lodging and meals are not included, but attendees get a special rate if they stay in rooms reserved for the event.

SIZE: 14,000 attendees, 600+ classes/workshops, 200+ instructors

Yes, you read right—14,000 attendees. They come from every state in the U.S. and from forty countries. Bead&Button is held for eight days in June in Milwaukee, Wisconsin. 2010 was its tenth anniversary. Marlene Vail, who organizes the show for Kalmbach Publishing, publisher of *Bead&Button* magazine, says, "When we purchased the magazine in 1996, there was a small show associated with the magazine called Embellishment. As the magazine grew, so did the show, and we christened it Bead&Button Show in 2000. We have been growing strong over the last ten years. We knew when we first did the event it was going to grow!"

Everything's Bigger

Just saying that Bead&Button is a big convention doesn't begin to explain the scope of this experience. Its official beginning this year was on Saturday, June 5. From then until Tuesday, attendees could choose from more than one hundred Master Classes, designed for intermediate and advanced students, or special three-day workshops for beginners. Then, starting on Wednesday, the general-education classes begin. They run from Wednesday through Sunday, from 8AM until 3PM with an hour for lunch. Altogether, there are 640 class offerings at Bead&Button this year, an all-time record. This is mind-boggling to me; 640 classes from which to choose. How does anyone ever decide?

Marlene Vail's advice to attendees: "Plan your days at the show, allocate how much time you want to spend in the classroom, what techniques are important, what your budget is for classes, what your budget is for shopping. Don't overbook yourself; allow some down time in between. Wear comfortable shoes and come with beading/jewelry buddies."

Wednesday, June 9

We leave Valley Ridge on Monday and go to Manitowoc, Wisconsin, where we have a book signing at Kim Gieser's shop and studio, Persimmon's Cottage, and get to hang out with Kim and her wonderful friends. We have an excellent time, and then, today, we leave Manitowoc and drive south along I-43 to Milwaukee. Although we can't actually see Lake Michigan for most of the journey, we know it's there, huge and amazing, just to the east.

We check into the Doubletree Hotel in downtown Milwaukee, catty-corner from the Midwest Airlines Center where Bead&Button is held. When I made the reservations, I thought this was going to be near the airport—I thought "airlines center" meant that's where it was. No. It's one of those buildings that's sponsored by someone else—so this is a downtown convention center sponsored by Midwest Airlines. It's nowhere near an airport.

I can't remember if we've ever stayed in a Doubletree, but I love it immediately. When you check in, the desk clerk opens a drawer and hands you a warm chocolate chip cookie. When I tweet about how delicious this cookie is, someone from Doubletree's corporate office responds, saying, "Hey, you can get one anytime—just ask!" Whoa—a warm chocolate chip cookie anytime, just for asking? Sure enough: we unpack and go downstairs to meet Tonia, my editor, who's staying across the street at the Hilton, and stop by the front desk and ask. Voilá! Another warm cookie! I love Milwaukee!

We meet Tonia at Starbucks, off the lobby of the Hilton, and then head out to find food. She remembers a nearby restaurant that has terrific pizza but isn't sure exactly where it is—only that it's really close to the entrance of the Hyatt Hotel. It's a nice evening, so we don't mind walking around looking for this restaurant—never mind that we're not exactly sure where it is and don't really know the name and are unfamiliar with the city, and . . . We do finally find it and have a wonderful meal of wine and pizza, involving a pizza-eating contest that Earl wins, and then we head over to the center for Meet the Teachers. We go into the Hyatt and take the skywalk over.

The Hilton and the Hyatt—Bead&Button's host hotel—are both connected to the center by skywalks, so you can cross from your room to the center without ever going outside. This is especially nice late at night when you might not want to walk around downtown. It's really confusing to me, though, and we spend a lot of time finding a hallway, wandering down it for a little ways and then going, "Nope, this isn't it."

The center is a big place—a really big place. We spend a lot of time wandering around here, too, riding the escalators. But it's not annoying. It's cool and clean, and everyone is friendly, and getting lost on the wrong skywalk somehow feels like an adventure.

I always love the Meet the Teachers events. Everyone's so excited about what's ahead, and everyone wants to meet their favorite teachers. This one is particularly cool because people are selling their work, so not only is there meeting the teachers, but there's shopping from the teachers, as well. Who can resist?

We find several artists we know—Robert Dancik, Susan Lenart Kazmer, Thomas Mann—and we meet Christi Friesen, whom I've interviewed for *Belle Armoire Jewelry* but have never met in person. I love her immediately. She's just as outgoing and hilariously funny in person as she was on the phone. I'd love to hang out and get to know her better, but this is one busy woman, with a full teaching schedule, plus a booth for vending. Good thing she's all energy, all the time.

Christi Friesen

"Bead&Button is a wonderful event. Even though I know I'll be working my butt off (and that's a lot of butt!), I eagerly look forward to the show every year. The venue is perfect, and the crowd is wonderful. I love being surrounded by interested, informed, beady gals fondling my creations and asking me how I make them. Since I also teach, the show is also a time to interact more directly with fellow artsy souls. It's bead-tastic!"

Some of my favorite people are the ones you don't usually really get to know. They're the assistants and managers and go-to people for the more-well-known artists. Thomas Mann would have a hard time doing everything he does if it weren't for Angele Seiley, and Susan Lenart Kazmer did a really smart thing when she brought Jen Cushman on board. People who don't get a chance to talk to their favorite artists don't realize that the other people in the booth, or in the back of the classroom, are often even better sources of information than the more-visible star. That's their job: to know the art and the materials and the techniques.

Retreat Niche

You don't need to create a mini retreat that covers all the bases in mixed media—paper, fabric, clay, paint. You can focus on one medium, like beads. Or art quilts. If you have a local group geared to that medium, they'd be the perfect co-conspirators for a weekend retreat. There's probably someone there who has teaching experience, maybe someone who's organized small-group retreats. Maybe someone with enough room in her house to host a small group—it never hurts to ask around.

107

Jen Cushman

"When I first began learning about mixed media, I saved all my extra money so I could attend art retreats locally or within a few states of my hometown. I taught myself how to do mixed-media art—collage, assemblage, and jewelry—by learning at the feet of the masters. In my opinion, this is the real benefit of big shows, such as Bead&Button: being able to take classes from excellent and knowledgeable teachers who are all working artists themselves.

"As my skills improved, I began to create and teach my projects and techniques. Then I joined Objects and Elements as the Director of Education and Marketing, meaning I now get to travel with our company to the Bead&Button Show and other art retreats where we choose to have retail booths.

"I learned the life I thought was très glamorous is not quite as I had thought. Don't get me wrong—being a vendor is great. You get to network and reconnect with friends you would never see unless there was a show to bring you together. Behind the scenes, however, it's also *a lot* of hard work and preparation.

"Since seeing what it takes to put on art retreats, particularly large successful ones like the Bead&Button Show, Art Unraveled, Art & Soul, Artfest, etc., I am even more humbled by the amount of work, dedication, and unconditional love that comes from the event organizers. Let me tell you, there are a lot easier ways in this world to make money. These people do it out of a passion for art, as well as a way to indulge their creativity.

"If there's advice I could give someone who hasn't attended many art retreats, it's this: Be kind to the people working the booths. Be respectful, because the unknown person behind the counter taking your money in exchange for your new art supplies

might just be one of the most knowledgeable and helpful artists you could have the pleasure to meet at the show.

"Also, like my mama always told me, say 'please' and 'thank you.' As a vendor, shows bring long days on your feet. Life goes a lot easier when your customers bring you true pleasure. It makes a successful vendor want to work even harder.

"The last bit of advice I can give is to be sociable. Have fun. Excitement and passion are contagious. When all parties involved are having fun, it makes for an all-around wonderful (and sometime life-changing) art experience."

Thursday, June 10

Since we've never been to Milwaukee before and are staying right downtown, we spend the day walking and getting to know this little part of the city. We walk over to Lake Michigan, which seems odd: We walked on the shore in Manitowoc, and then we drove a couple hours south, and we can *still* walk on the shore. That's one big lake! Something even Texans can't claim to beat, size-wise. The Blue Angels are practicing, and we spend an hour watching them fly over, which is really cool.

We ask around for suggestions for a bar with a great view and are guided to the historic Pfister Hotel, with Blu, its twenty-third-floor bar, where we can see even more of the Blue Angels' practice session. I'm quite taken by the women's restroom, which has a stall on the end that's by the window, with a spectacular view. Our waiter tells us it's a prime spot for not-so-secret rendezvous. Um. Romance in a public restroom? Nah.

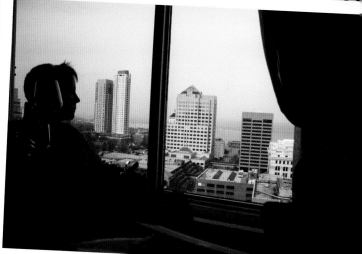

Thursday evening we use our super-duper passes to get into the Private Shopping Preview for registered attendees—the market opens to the public on Friday—and wander around ooohing and ahhing at all the fabulous stuff. OK, only one of us oohs and ahhhs; the other gritches because the only photos he's allowed to take are of vendors we know personally. It's not like the retreats where we know everyone and they know us and photography is no big deal. Here, it's a big deal. That's OK, though, because we get some good shots of people we *do* know, plus we have an excuse to stand around and talk to them and see the visitors who stop at their booths. Thomas Mann and Angele Seiley have a saw demonstration going on, and it's fun to watch people sit down and gingerly take the jeweler's saw and then discover it really doesn't bite after all.

109

How Classes Are Chosen

Marlene explains that the Bead&Button staff begin in August choosing workshops for the next year. Out of more than 2,000 pieces of jewelry submitted, they pick just over 600. "The pieces are chosen based foremost on design, then fashion, demand for types of media and techniques, and the teacher." She says that since so much of what drives jewelry is current fashion, the biggest help would be if they had a crystal ball and could see what fashion trends would be popular ten months ahead.

Friday, June 11

On Friday, Earl hangs out in Tonia's class. Since there are so very many workshops offered, the classroom set-up is a little odd: the huge halls and ballrooms are subdivided with curtains, creating lots of little "rooms" with no real walls. It's noisy, but it seems to work: everyone seems to be having a great time.

Teaching at the Bead&Button Show

Teaching at this venue is a bit different from teaching at the mixed-media retreats, as Tonia explains. "For one thing, the application process for this event is handled entirely online, and the process is the same for everyone—seasoned and new instructors alike. They make it very easy for you to think about your supplies/materials lists by providing a standardized list of items you can just check off. The event in general is extremely well organized—it has to be with so many instructors and classes.

"Another thing that's different about this venue: there are a lot of shorter classes offered in addition to all-day classes. I've learned that you have to be even more organized and creative when it comes to teaching a one-hour class than you do for teaching a longer one where you have time to loosen up and get comfortable with your class.

"Finally, I really love the location of this show. Milwaukee is such a great city, and there is so much within walking distance of the Midwest Airlines Center—top-notch restaurants, the river walk, and plenty of activity—much like you'd find in any large but well-loved city. I recommend anyone who can teach jewelry classes to give this show a try."

We spend most of the day in the vendors' hall, talking to people, looking at their work, shopping (that would be me). I find a man selling smooth stones that have been drilled to be worn on silk cord. He has all different sizes, and I'm entranced. I love rocks anyway, and these are like silk, they're so smooth. Still, I feel a little silly: I go to the biggest jewelry show in the world and spend a whole day at the marketplace, and what do I buy? I buy rocks. I think perhaps I won't tell anybody this. Coupled with my having paid to ship home rocks from the beach at Artfest, it begins to look a little obsessive.

Oh, Go Ahead and Shop!

The thing that's so compelling about shopping at these conventions and retreats is that you can find things you can't find anywhere else. Oh, sure, you might be able to find most of it online, but you wouldn't be able to pick it up and look at it and handle it before you buy.

It's not just art, either. Many vendors sell the supplies and tools they use to create their work, so you can ask questions and maybe—as in the case of Thomas Mann's jewelry saw—even try it out before you purchase.

While you can, theoretically, go to a vendors' market and not spend a penny, I'd advise starting a little stash of cash way, way ahead of time. Most people take workshops, learn something new, and then buy the tools and supplies they'll need to practice their new skills once they get back home.

Saturday, June 12

It's time to head out. This is our last art retreat on this particular trip, but we've still got a long, long way to go. We've got book signings in Maine and New York City. New York City! We've never been, so I've arranged for us to spend several days there to celebrate our anniversary. It's many, many miles away, though, so we leave Milwaukee—reluctantly, because we really like this city a lot—and hit the road.

Heart of the Desert
Art Unraveled, Phoenix

WHERE: Embassy Suites, Phoenix, Arizona

WHEN: Early August (Monday–Sunday)

WHO RUNS IT: Linda and Chuck Young

COST: Classes are priced individually, and rates vary ($125 and up). Lodging and meals are not included, but attendees get a special rate if they stay in rooms reserved for the event.

SIZE: 350+ attendees, 100+ classes, 50+ instructors

I love Art Unraveled; it's the only art retreat where I'm pretty much guaranteed I won't freeze. Even though the Embassy Suites, the host hotel, keeps pretty chilly with the air conditioning blasting 24/7, I can walk outdoors any hour of the day or night and experience August in Phoenix. I love this because I love warm. Art Unraveled is unique. It's one of the few retreats held in the summer, and it's the only one in this part of the country. It draws a really loyal group of teachers and attendees, and instead of Vendors' Night, there's an all-day-Saturday shopping extravaganza.

Tuesday, August 2

We arrive in Phoenix at some unknown time in the afternoon, the sun blazing, the Embassy Suites welcoming us like an oasis in the desert. Um, because it *is* an oasis in the desert. I love Embassy Suites! I read somewhere that you can't call something a "retreat" when it's in a hotel. I say, "Why not?" In Phoenix, in the summer, you can get great rates, and if you don't have to leave the hotel, you won't suffer at all. The pool! The bar! The onsite store! It's perfect for a retreat.

Why don't I know what time we arrived? Was I drunk, perhaps? No. I am just completely discombobulated by time zones. Usually Arizona is on Mountain Time. But Arizona chose not to recognize daylight savings time, so in the summer it's theoretically Pacific Time. The clock in the truck is still set on Central Time. I spent the afternoon, as Earl drove, e-mailing and talking on the phone to an editor on the East Coast, who sent me a note saying, "I'll call you at 2:40," causing me to look helplessly at the clock on the dashboard, then the clock on the iPhone, which had reset itself with each time zone change, and then her note, trying to figure out what time "2:40" actually was.

I never did. I just sat and waited. She called, but I don't know when. And I don't know when we arrived in Phoenix. But we did arrive, safe and sound, and nobody was stuck in melted asphalt in the parking lot, like dinosaurs at the La Brea Tar Pits. It was 117 degrees outside, but inside was fabulously cool and welcoming.

We meet Susan Lenart Kazmer and Melissa Manley in the lobby and hear the story of Traci Bautista's arrival earlier the day in the stretch limo, which seems a bit much until you hear the rest of the story: you can take the limo from the airport for just $10 more than you'd pay for a regular taxi, so why not? We talk to Lisa Pavelka, and I realize once again that Richard Salley is exactly right: it's like a family reunion at every art retreat, where you see people you haven't seen for a month or two and catch up on what they've been doing in the interim. Teachers, students, vendors—you get to know each other and look forward to seeing what everyone's been up to, even if it's just been a couple weeks and all they've been doing is unpacking from last time and repacking for this time.

We make a quick trip to Whole Foods to lay in a supply of salad and healthy stuff, plus some chips and an amazing fresh organic fruit cobbler. The woman who baked it is entranced by our colors—I'm in turquoise and yellow with fuchsia heels, and Earl is in purple and hot pink—and we tell her about Art Unraveled and the vendor event on Saturday, which is open to the public, and she insists Earl try the hot cobbler, fixing him a little cup and topping it with ice cream. Of course, we are then forced to buy some, never mind that we're trying to be really, really healthy. Hey—it's organic!

Back at the hotel, we hang out in the lobby, talking to Don Madden, whom we first met at Adorn Me! in Houston, and his wife, Susan, whom we got to meet at Art & Soul in Virginia. A large group has pulled up chairs to make a circle in the lobby, taking advantage of the free drinks at the Manager's Reception, and everyone talks about what they've been up to.

Don Madden

"I really enjoy going to Art Unraveled and Art & Soul art retreats. There is no pressure on you to produce, just encouragement to try new techniques. Everyone is friendly and helpful, and I've made a lot of new friends every year. Of course, it doesn't hurt to be one of the very few men attending."

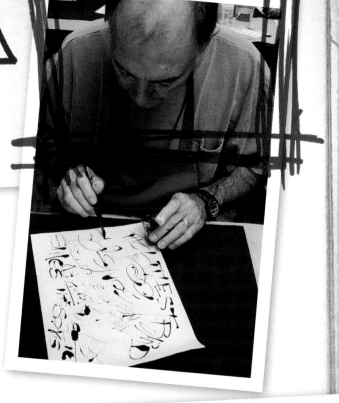

Wednesday, August 3

I spend the morning in the room, working on my laptop. Although I'm not big on staying in hotels, I love working in the Embassy Suites—this one has a balcony, and light comes into the room where I've set up the MacBook. I can get so much done without the distractions of the cats inviting me to play. Earl goes down to scout out workshops for me to check out later.

We don't eat lunch, but here they've made it really convenient for people in the workshops: You can preorder in the morning, and the on-site restaurant will have your order ready for you when class breaks at noon. No waiting, no rushing to get back to class.

Note

Even if you don't drink alcohol, the nightly Manager's Reception, typically from 5:30 to 7:30 each evening, is an excellent place to meet people and catch up. The drinks are free, and you can just as easily get juice or a soda as you can wine or a mixed drink. If you're shy, bring your journal; it's a great opportunity to make notes or sketches or just plan your weekend, and lots of times other journal people will find you, which is really cool.

Classes resume at 1:30PM, and I go down to check out what Jill Berry's doing in her Journal Texting workshop. Turns out it's not about how to text someone about journals, or how to text journal entries to yourself. It's about how to get text into your journals. Jill sits me down and forces me to play, which is oh, so difficult. Snort. She lets me play with her Pitt Artist Brush Pens, and oh, my, I'm hooked!

Note

If you're not crazy about restaurant meals, you can get the Embassy Suites shuttle to take you anywhere within a 5-mile radius, which includes both Trader Joe's and Whole Foods, among others. With a mini-frig and microwave in all the rooms, you really don't have to worry about what you're going to eat.

Get It While It's Hot!

One of the coolest—and most dangerous—things about art retreats is getting to check out other people's art supplies. I have never, ever been to one of these without finding something that I *had* to have. And let me just say right now: if you find something you think you'll love, and it's available at the onsite store or from one of the vendors, and you can afford it without having to cash in your airline ticket for the trip home? You'd better get it. Because I can almost guarantee that once you get home, forget about finding it or ordering it online. Either you'll have misplaced the web address, or they won't have it anymore, or it will be back-ordered for the next three years. Guess how I know this.

Wednesday night we go to dinner with Tonia Davenport and Mary Beth Shaw, and then we head back to Quinn McDonald's journaling class, "Raw Journaling: Writing for the Perfectionist." She hands us folders with paper, cover stock, thread, and binding instructions and tells us we'll complete our first journal: for many people who've signed up to take this class, finishing something—anything—is very difficult, as is often the way with perfectionists.

Not Just Art

In addition to art technique workshops, more and more retreats are offering a variety of workshops that are not about making a piece of art. Lisa Pavelka offers an evening workshop on Getting Published, and Quinn's class is designed to help artists get past their own perfectionism and procrastination. This seems to be a growing trend, with increasing offers of writing workshops, social networking classes, and opportunities for inner exploration, often through journal writing. I like this trend a lot.

Finding a Class that Fits

Even if it sounds like a class might not be your thing, read the description carefully: the name may not tell the whole story. Or there may be one instructor from whom you've been dying to take a workshop. Or two. Or three. There's no rule that says you have to have variety in life. It's perfectly OK to have a whole week of classes by just one artist or in just one medium. Of course, those classes may be full, so make sure you have some backup choices.

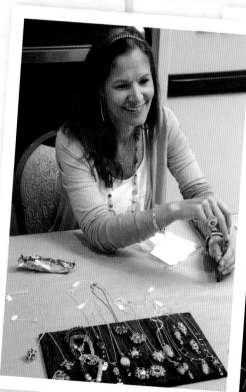

Quinn tells about her very first year at Art Unraveled, where a perfectionist calligraphy teacher told her she was "too old" to learn calligraphy because she wouldn't have enough time left in her life to perfect her calligraphy practice. The woman next to Quinn turned to her and said, "This woman has letters, but you have words." She took that to heart and began to think about the ways she could use what she was best at and let the rest go.

She says we are all "recovering perfectionists," and she offers a series of exercises to help us think about our perfectionism. We make lists of what we like and don't like about being a perfectionist, and she talks about her own experiences. In another career, she did some work with the FBI and CIA and helped them think about ways their tendencies toward perfectionism could work for them. So the workshop gets us to think about how to overcome some of the more limiting aspects of perfectionism while embracing those parts that can help us achieve our goals. At one point Quinn tells us, "We don't find meaning in life. We make meaning in life." This sounds good to me.

Quinn does a great job, and her anecdotes are both amusing and enlightening. I realize once again, however, that I am not a good class-taker. I grow restless, and I'm not very good at being in groups where people are exploring difficult feelings. I have to squelch my love of being the class clown, which is never easy for me. I think how glad I am that, when I was teaching workshops, I never had myself as a student. Yikes.

We finish up by sewing the papers into a book using a pamphlet stitch, and we discover that we have, indeed, finished a journal.

After class Earl and I head out to Whole Foods to find more stuff to eat. In case it's not obvious, we don't live anywhere near a Whole Foods or a Trader Joe's (the latter doesn't even exist in Texas yet), or even a Central Market, so when we travel to places that have these, we spend a *lot* of time in the deli. A salad, some sesame tofu, pizza for Earl—yum!

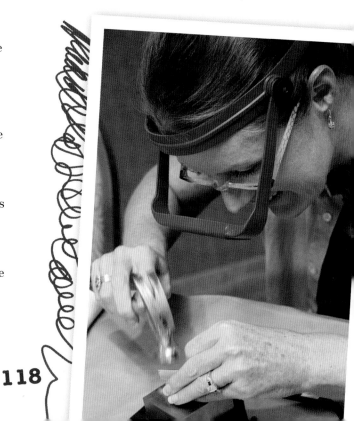

Thursday, August 5

I wake up about 6AM, or at least what I think is around 6AM. I'm still confused about the time differences. I love working in hotel rooms—I can get a lot done before noon, when I venture down to see what's going on. I try not to go into classrooms in the morning, when people are settling in and getting to know the instructor and each other. After lunch, though, things usually loosen up enough that I'm not an interruption. Of course, I'm careful whose classes I visit. I've learned that not everyone welcomes visitors.

Behind Closed Doors

Some workshops are very loose and open, with people moving around and chatting, sharing supplies and stories and snacks. There's music and laughter, and visitors may wander in and out. Other workshops are much more intense and focused. Sometimes this is because there are really technical instructions being given and really intricate processes to master—some of Keith Lo Bue's workshops, in which he's teaching a complicated technique, are like that. Students need to pay attention to what they're doing, and the tools need both attention and respect. Still other workshops, like some of the journaling ones, are more emotionally intense, and the instructors want to create a safe, quiet, private place for their students.

Ask around to find out which are which, if that matters to you. If you like things loose, choose classes that fit your personality, and if you're wandering around on a day you don't have a class, respect closed doors: if the door to a workshop is closed, don't open it and peek in. If you need to go in for some reason, knock quietly.

We talk to Susan Lenart Kazmer and her team at their Objects and Elements booth, set up in the office area outside the ballrooms/classrooms. Susan drives me nuts: She has the coolest bag, and when I ask where she got it, she says, "France!" Later I notice her way-cool little shrug, and I ask where she got it. And again she says, "France!" She tells me I just need to come with her to France so I can shop. Yeah, right. That's *exactly* what I need to do: book a trip to France to shop. But imagine: a trip to France with Susan and her team, with workshops and shopping! Oh, my.

Earl's been spending time in Jill Berry's workshops. Wednesday she did Journal Texting, which was way cool. Today she's doing Sumptuous Sumi, and while sumi ink may not sound that exciting, the stuff they're doing is amazing. Jill's the kind of instructor who makes me want to forget everything else and just sit down in her classroom with my journal and play. Her students have huge feathers and shells and all

Broadening Horizons

The cliché is that travel is broadening—that you learn by traveling and seeing how other people live. The same is true of attending art retreats, where you get to see how other artists dress and what tools they use and what supplies they like. You may notice that most people are wearing really cool aprons—both to keep their clothes clean and because, really, they just look cool—and be inspired to go home and make an apron yourself. You may be inspired to start a journal after seeing how many people carry theirs everywhere and make notes and sketches of everything, all day long. The cliché, it turns out, is true.

kinds of tools for mark making, and the sumi ink does really cool things.

We stop in and visit with Daniel Essig, who's teaching a variety of classes at Art Unraveled. Some people have come in just to take his classes, and they sign up for every single one he offers. Wednesday morning he did his Centipede Stitch class. It's all filled up, so I'm glad we get to offer it here (see page 95). In the afternoon, he taught his Mica Cover Book—the mica is way popular, and everyone's glad he brought a bunch of it for sale. Today it's the Back to Back (Dos-a-Dos) Book, another popular book structure.

We check out Lisa Renner's "Wadaheckerdiez" (What The Heck Are These) workshop, with its sculptural/doll/figure people. Don Madden insists that he's man enough to be able to call them "dolls" instead of trying to think of something else to call them. Whatever you call them, they're pretty cool.

Friday, August 6th

Earl spends the morning in Keith Lo Bue's workshop, "Back On the Chain Gang," where Keith teaches students how to create chains from scratch. We check out Mary Beth Shaw's workshop, "Moving in the Right Circles," where she uses Wood Icing, a textural medium that gives great dimension to collage and painting.

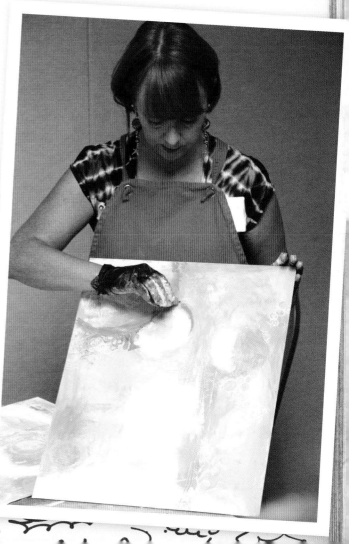

I spend the afternoon with Tonia, exchanging ideas and visiting with the artists who come by the lobby. After class, Michael deMeng organizes a field trip to the Buffalo Chip Saloon and Restaurant in Cave Creek, a little town way out in what feels like the middle of nowhere when our multi-car caravan finally arrives. The saloon also features a rodeo arena and bull riding, so there's something for everyone. Earl and I dance, along with Annie Lockhart and her husband, Dan Carrel. Michael deMeng, Keith Lo Bue, Daniel Essig, Karen Michel, and another table full of Art Unraveled people order hamburgers and beer and take photos of each other. Then we all hike out to the arena, past an outdoor barbecue buffet, to watch eager young cowboys try to ride big, angry bulls. Earl rode a bull in college, and he explains the finer points to me. I cringe, feeling sorry for the bulls. It looks exciting, though. Maybe mechanical bull-riding is the way to go.

On the ride back to Phoenix, we exchange stories about venues and organizers and shop owners, both the good and the bad. I think some of them would have treated people better if they'd had any idea how word about them spreads. Everyone makes mental notes about shops where you probably don't want to bother teaching and agrees that art retreats are the best venues, for many reasons.

Saturday, August 7

It's Vendors' Day—yay! I love Vendors' Day beyond almost anything, as I might have mentioned a time or two. The energy is amazing, from the artists setting up their booths to the shoppers waiting in line for 10AM to arrive. Everyone's in one place, sure—that makes it easy to see all of your favorite artists, say hi, pick up their Moo cards or business cards, see what they've been making since you last shopped their booth. But the real thrill, of course, is the shopping itself—buying things directly from the people who make them by hand. You know who's getting the money, and they know who's getting their art. What I like best about vending at Art Unraveled is that it lasts all day long. Although it can be exhausting for the vendors who have to get there early in the morning to set up their booths and then sit there from 10AM to 4PM, talking to customers and students and fans, it's wonderful for the local community. When vending takes place in a couple hours on one night of a retreat, it's difficult for people in the community to make time to get there.

122

But when it's all day on Saturday, people who would otherwise have no reason to know about the art retreat going on in their town now have time to come by and discover a whole new world. And, of course, shop.

I love walking up and down the aisles, looking at everything, and then going back around later and finding out how people are doing. How are sales? How's the crowd? Today they tell me the crowd is good, the energy is good. Sales are odd, some say: while smaller works sell well, many of the larger pieces—the more expensive pieces—don't do as well. This isn't universally true, of course: some vendors sell original pieces for several hundred dollars. On the whole, however, things priced under $50 do best.

In the afternoon Earl and I take a break around 2PM and head over to the mall to get something cold to drink and to do a little shopping. Apparently the Dillard's here is legendary—someone tells me that this time of year, when it's hot in Phoenix and many people have left town for cooler geography, is the best time to shop. I don't know if the prices are better or if it's just that the stuff on sale doesn't get snatched up as quickly as it would in, say, January, when the snowbirds are in residence. I talk to someone else who's just arrived from the airport and is heading over to the department store even before she unpacks. Gotta make that annual trip to see what's on sale, she tells me.

Tonight is the Carnivale Time Dessert Party with live music and dessert, a cash bar, a fashion show, and a mask-making party. We don't go to this because tickets for two would be $70, an admission cost that appears to be daunting for a lot of attendees, many of whom make other plans for the evening. We hear good things about the event later, though.

We spend the evening in the lobby talking to Dale Wigley, who entertains us with marvelous stories of the trans-Canadian train trip her kids gave her for her eightieth birthday this summer. She got to walk on a glacier, and even though I hate cold (and she says it was very, very cold), her story makes me want to hop on a train for the Canadian Rockies.

Dinner? Raw vegetables and hummus in our room. Maybe not exciting, but very healthy, so you go to bed feeling both virtuous (for having skipped the free chips-n-cheese at the Manager's Reception) and healthy. This is a good retreat for me: I'm eating well, getting plenty of sleep, and getting a ton of work done every day. Plus getting to see everyone—people here, more than anywhere else, seem to congregate in

High and Low

It bears repeating here: If you're vending, think about a variety of price points. Try to have at least something that's priced low, even if it's just postcards with photos of your work.

124

the lobby in the evenings. Maybe it's because it's too hot to go anywhere else, but whatever the reason, it's wonderful: you can grab a chair and hang out and see almost everyone as they come in after class. Now if they just had big tables set up so people could spread out their projects—that would be so cool.

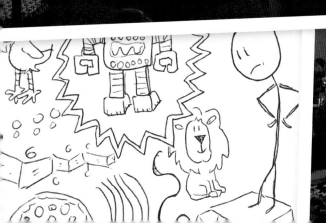

Sunday, August 8

The first thing I hear every morning when I wake up is the "clink" of a titanium driver making contact with a golf ball. To me, from my room on the fourth floor, it sounds *exactly* like the clink of two Coke bottles tapping together—the old glass kind you never see anymore. I love this sound. I haven't had a Coke in years and years, but this makes me want one. So I'm waking up every morning happy, thinking about icy cold Coca-Cola.

I spend the morning in the room writing. I love this so much. I get a lot done up here by myself, but I still feel connected: Everything's going on just a few floors below me, and I could easily get on the elevator and go down and find a class on metal soldering or encaustic or journaling. It's cool to be so close to so much creativity, even if you're not in the middle of it.

At one point I meet up with Earl, who's been photographing workshops, and we're standing by the elevators when a man walks by and Earl says, "Tom Brahaney?" and sure enough: it's a guy with whom he played high school football in Midland in 1968. This happens a lot. We've run into his former students at Carlsbad Caverns, in the pool at a hotel in San Antonio, at Disney World. We've run into a former neighbor getting off the ferry in New Orleans. He knows *a lot* of people. Seeing Tom is lots of fun for Earl, but then he has fun at every retreat. In another life, I think he'd want to run his own, just to be right in the middle of all these creative people.

After lunch, I find Ruth Rae's workshop, "The Journey," and watch her demo how to make cool, funky hearts by burning craft felt. There are several workshops along this hallway where people are drying or burning things with heat guns, and the odor is kind of intense. It would be ideal to have outside spaces for some of the workshops, but the 110-degree-plus heat would be a little warm for that, I'm thinking.

Allergic?

Take into consideration any allergies or sensitivities when choosing workshops. Although most instructors are aware of health issues, not all may be as aware of fumes and dust as you are. If you have a respirator and think you may need it, pack it and take it along. If you're concerned about health issues, e-mail the instructor and ask about what precautions will be taken.

Sundays are kind of sad because people who have to head back to work tomorrow are checking out. The parking lot is a lot emptier, and things seem more subdued. On the other hand, some people—instructors and students—are just now checking in for Sunday night and Monday and Tuesday classes, bringing new energy to the end of the weekend.

I find Melanie Testa's stamping workshop, "Stamps in Depth," and visit with her during lunch. We make arrangements to meet in the lobby after her class. She's wearing a cool skirt she made from a pattern she made from a skirt she bought in New York City. (Got all that?) She finds clothes she loves and then makes a pattern from them so she can make her own version. I love this woman! She's wearing a T-shirt with an appliqué of a transfer of the image on the art quilt she's working on for the International Quilt Festival in Houston.

After class we hang out and catch up. Some people think that when instructors hang out together at art retreats, they're being cliquish or aloof. What they're usually doing is talking about class proposals and travel and working on their next book. They're talking shop. Networking. For many of us, this really is a full-time job, all day every day.

127

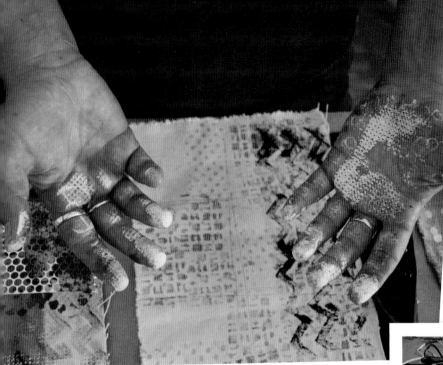

Monday, August 9

Melanie invites us into her "Soy Wax Batik with Paint" workshop, so after a morning working in the room, I go down to join Earl, who's taking photos. Walking down the hall, I pass rooms with wafts of various chemical odors, and then suddenly, I smell something lovely. I step into Melanie's room and immediately ask, "Omigod, what *is* that smell?" It's the soy wax, they tell me, and I try to figure out what it smells like when someone says, "White chocolate, huh?" Indeed. The whole room smells of candy—not in an overwhelming way, but as if someone's been passing around a tray of snacks. My stomach growls; this is a workshop where the odor is a good thing!

Melanie sets me up with some fabric and my choice of old kitchen implements (she says you want to scout estate sales and flea markets for great things like metal potato mashers and a bunch of other tools that are, to a noncook like me, completely baffling). She lets me stamp and paint and make my own little mess—along with a couple of really cool prints—and then we have to leave for another meeting. (She keeps the prints laid out to dry and brings them to me later, in a plastic baggie, and tells me how to heat-set them and then remove the wax by washing them.)

Tuesday, August 10

Time to go home. There are still workshops going on today—Michael deMeng, Keith Lo Bue, Richard Salley, and a handful of others are still hard at work—but many people have headed home. It's always hard to leave art retreats, knowing there are some people you've met and talked to whom you may never see again. For us, this is our last pure mixed-media retreat of the year, so it's especially poignant. While everyone else is planning to see each other at Art & Soul in Portland in October, we're going back to Midland and won't be going anywhere else except Houston.

And that's the fun of it. Even as one retreat ends, there's always something else to look forward to: the same retreat next year, another retreat in a couple months, a local workshop, an online tutorial, a virtual retreat. With a little digging, you can find something somewhere that's going to change your life, in ways big or small or both.

129

Inspiring Stitches
International Quilt Festival, Houston

WHERE: George R. Brown Convention Center

WHEN: Houston: early November; Cincinnati: April; Long Beach: late July

WHO RUNS IT: Quilts, Inc. (begun by Karey Brensenhan, founder and director)

COST: Classes are priced individually (in addition to a $38 registration fee), and rates vary ($35 and up). Lodging and meals are not a part of this show. Admission to the festival is $10 per day/$35 entire show.

SIZE: 52,000+ attendees, 350+ classes, 120 instructors

The International Quilt Festival has three incarnations: Houston, Cincinnati, and Long Beach, California. I've gone to the one in Houston for years and wanted to include it here because, well, it's fabulous. Simply fabulous. Even if you don't quilt (I don't), there's plenty here you'll love: the overlap in mixed-media art is such that tools and supplies and techniques designed for one medium are essential parts of many others. And looking at excellent work in any form—sculpture, painting, mosaic, quilting—is a rich source of inspiration for whatever it is that you do. The real reason I wanted to include this festival, though, is that it's just really fun. I was thrilled to discover it, and I tell everyone I can about it. It's that good. Plus some of the instructors from the mixed-media retreat circuit—such as Melanie Testa and Leslie Riley—teach at the festival.

The Shopping

Never underestimate the importance of shopping! I'm not being facetious here; if you live somewhere out in the middle of nowhere and the only way you get to shop for tools and supplies for your art is online, you know exactly how wonderful it is to be someplace where you can actually see those supplies and tools and touch them and ask questions about them and compare them and have a real, close-up idea of what it is you're going to buy. Sure, Internet shopping is a wonderful thing, and for many of us, it's the only way we'd ever be able to acquire the things we need to do what we do. But touching the fabric? Trying out the drill or the saw? That's a whole nother thing, and it's not inconsiderable. At Festival, you can buy anything from a long-arm quilting machine to antique buttons, wearable art to comfortable shoes, vintage rhinestones to hand-dyed wool.

52,000 Attendees

Rhianna White, New Media Coordinator for Quilts, Inc. explains the festival's draw. "International Quilt Festival draws over 52,000 people to the city of Houston each year, many of whom have traveled internationally. In fact, at this year's show, we had attendees from 42 different countries. Many people—especially those with a real passion for quilting—will make their trip to Festival a vacation of sorts—traveling with family members or a group of friends.

"We also continually strive to draw non-quilters to the show and to expose the wonderful art of quilting to those who may not know what the art form truly looks like today! Time and time again, we hear from people who say, 'I had no idea that a quilt could look like this!' If you appreciate art, or if you like to shop (and who doesn't?), we would encourage you to come to the show. You certainly don't have to be a quilter! It is our goal to promote the art of quilting, and the more people that see what quilting has to offer, the better!"

Friday, November 5

We arrive in Houston right in the middle of rush hour. I have no idea how this happens, but it does: No matter which direction we come from or when we leave, when we are heading to Houston, we're going to arrive there between 5 and 6PM. Period. It's a curse, I'm sure. This time we're coming in from New Orleans, where we've spent four days with Katherine Engen, of Valley Ridge, accompanying her as she scouts shops and museums and cool places for the students who're taking Michael deMeng's workshop there in February. We have a marvelous time, and we spend one evening with Thomas Mann, who prepares an elaborate four-hour dinner in his home, the former Rose Tattoo bar. After a wild 1:30AM taxi ride through Uptown back to our hotels, though, even this Houston traffic seems tame, although there's sure a lot of it.

Once past the traffic, we pick up veggies at Central Market and head to our hotel for a quiet evening. After the nightlife of the French Quarter, this is wonderful, indeed.

Making the Connection

At the larger events, if you want to meet up with someone, you've got to make some plans. While it might seem logical that you'd eventually run into them, you could easily spend an entire weekend—or full week—being inside the venue but never crossing paths with anyone you know. Just saying there are a lot of people doesn't begin to cover it. You're going to need your cell phone for this one. And a map (these are provided in the festival program and at the front of the hall).

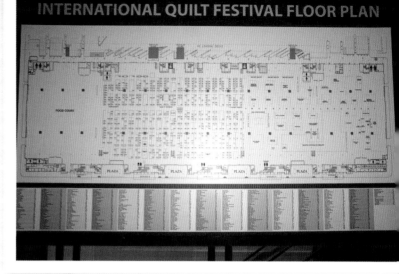

INTERNATIONAL QUILT FESTIVAL FLOOR PLAN

Shopping, Anyone?

If you're organizing a small local retreat with more than a couple dozen people, think about offering a chance to shop. You could arrange transportation to a local shop (as Art & Soul Portland does to Collage), or you might be able to have someone set up a table wherever you're having classes. Think about what would work for everyone; the vendor needs enough people to make it worthwhile, and the attendees need to be able to buy tools and supplies they need or might not be able to find anywhere else. While it's not always feasible, it's something to think about, especially if you know a local vendor who might want to be a part of your retreat.

Saturday, November 6

This is, I think, about the tenth year we've come to the International Quilt Festival. The first time, I came with friends on the way to Galveston, thinking a couple hours would be plenty to see all the quilts and vendors. I had no clue. When you step inside the doors of the George R. Brown Convention Center for the first time during Festival, your mouth literally drops open. I've seen it happen with other people, and I know it happened with me. It's impossible to imagine the sheer mass of people and booths and vendors and quilts and, and, and. I've heard there are 5 miles of exhibits and vendors, and I believe it. Every year we spend at least two days, and every year we leave without seeing everything. Of course, a lot of that is because we spend an inordinate amount of time schmoozing, standing in the aisles talking to people we haven't seen since last year. And shopping. Oh, my—the shopping. Even for people who don't normally like to shop, there is some shopping to be done here.

Restrooms

While restrooms seem like a no-brainer, sometimes you have to plan ahead. While the Brown Convention Center has a lot of large, nice, clean restrooms, if you're a guy, you may have trouble finding one you can use. For Festival, they change a lot of the men's restrooms to women's—women far outnumber men here, and it makes sense. But if you're a guy, you'll want to locate a men's restroom before you need it, since you may have to hike a ways to get there. I've got to say: the staff does a fabulous job of keeping all the restrooms clean and well stocked during the event. Kudos to them all.

If you've never been to a really big show or festival or retreat, you're in for a treat at Quilt Festival—and a shock. It's hard to imagine how many people can all converge on one building at the same time. With thousands of people and motorized scooters and baby strollers and bags and totes, it's a good thing they no longer allow wheeled suitcases on the show floor; there's simply not enough room.

You'll Need a Plan

For the big shows, it's not enough just to arrive. I've tried that, and I've left without seeing half of what I wanted to see. If your time is limited, make a list of the things you must see—the exhibits you know you can't miss, the vendors you've heard raves about, the suppliers of stuff you need to stock up on. If you have unlimited time, you may want to start at one end and methodically walk up and down every aisle, as I do; it takes a while, but it's good exercise, and you won't miss anything. You hope. I always manage to miss something: I get home and read online about something fabulous and realize I should have planned just a little more carefully. If you're taking workshops, you can plan everything else around those.

Melanie Testa

"As quilt shows go, Houston International Quilt Festival is the show to go to. The. Show. It is pretty awesome: who can beat eleven football fields' worth of quilts—and retail-sales opportunity to boot? The quilts are like eye candy—they are so numerous you need to be focused and directed in viewing them; otherwise you might get lost and subsumed and find yourself in an entirely different section than you had intended.

"As for the shopping, I like to be focused in that, too. I usually have a specific set of vendors that I *must* visit; this year it was Shibori Girls' booth, where I bought several indigo-dyed 'moons.' In previous years I have bought an ironing board (made to travel and the proper height to connect to your sewing machine table—just perfect for a tiny sewing room), and of course, needles, threads, and fabric.

"As for teaching at Quilt Fest, I prefer a smaller retreat where hanging out with students after hours is as easy as saying, 'Let's meet in the lobby,' but just like life in a big city, Quilt Fest can be just as intimate as the smaller retreats. The students are lovely, excited, engaged, and ready. And really, I am just plain happy to be employed as a teacher to students who want to know more, push themselves and their fiber art further and further! So it is all good—the big, the small— every student is an exciting student to me. And every retreat, every festival is an opportunity to meet up with friends, make new friends, view great art, and buy great stuff."

Our favorite place to hang out is in the Treasures of the Gypsy booth, with Gypsy Pamela (Pamela Armas), her consort, Ken, and her band of Gypsies. This year we're thrilled to see our friends Linda Rael and the fabulous doll artist Marlene Slobin. Pamela's booth is amazing. There's so much to see that you just kind of wander through it with your head bobbing up and down (many of the samples are perched on top of the display shelving, so you have to crane your neck to see them). Because she sells fabrics coveted not only by doll artists but by quilters and wearable artists, as well, almost everyone eventually finds their way to Treasures of the Gypsy, and we can hang out here and see them all, sooner or later.

Everyone's talking about the art dolls in the Treasures of the Gypsy Contest, so of course we have to hurry over to the exhibit area to see those. I was one of Pamela's judges two years ago and know exactly how tough it is to choose from among all the top-notch entries. It's fun this year to pick out work by my favorite doll artists: Neva Waldt, Arley Berryhill, Janet Bodin, and of course, Marlene and Linda. My brain goes on overload, so we take a break.

You Won't Starve

While you can't bring food and drink into the exhibit hall (never mind that we see people hiding drinks in their tote bags), there's a huge food court inside where you can find almost any kind of sustenance you need. And, please, don't be one of those people violating the rules: There's a reason food and drink aren't allowed on the floor. If you spill something on a quilt that just won a $10,000 award, the rest of your day is not going to be pretty.

Following Rules

While you want your own gathering to be fun and informal and relaxing, think about the things that could be disastrous: Someone spilling their glass of wine on someone else's drying canvas, or someone forgetting to turn off the dye pot on the stove. Sometimes the best way to prevent mishaps when you're sharing your studio with others is to print out a list of simple rules. Keep it short, make them upbeat and funny, but ask that everyone observe them and explain why. It's better to restrict snacking to the kitchen or the patio than to risk ruining someone else's work.

After we've been revived, I try on artwear, something you can't find just anywhere. I buy a batik jacket and an acid green coat, both machine washable and not nearly as expensive as you would imagine. And then we try to see as many of the quilts as we can before closing time at 7PM. We tried to do it all in one day this year, which—as I well know—is folly. But scheduling is tight, and you do what you can. Better one full day than no day at all.

The quilts are set up in their own area, and the difference between that half of the coliseum and the vending area is palpable. It's darker and quieter, and it's much, much colder. Everything is designed to focus on the displays of the most amazing quilts you've ever seen, from traditional pieced quilts to painted art quilts to small journal quilts and everything in between. We see work by people we know—Susan Shie, Tonya Brown—and by exciting first-time exhibitors. The craftsmanship takes your breath away. These quilts, like the one I saw belonging to Susan Cleveland—"Psychedelic Big Bang"—took months and months of steady, painstaking work, and it shows.

I always freeze in the quilt exhibits. I don't know if they keep the temperature lower for the quilts, or if it's just the lack of heat generated by all those credit card machines working nonstop that are over in the shopping area, but after an hour or two, I'm always numb and shivering. Most years, the weather is still warm in Houston during the last week of October, and you can go upstairs and sit on one of the balconies to warm up. Or you can get your hand stamped, leave the convention hall, and walk across the street to the green, where there's usually music or exhibits going on and a couple of nice places to sit with a cocktail or glass of wine.

Dress for Comfort

Wear layers, because there's nothing worse than being so hot or so cold you can't enjoy the exhibits. It goes without saying that you're going to wear comfortable shoes. And take a sturdy, lightweight tote that you can stash in your bag or pocket until you need to start filling it with your purchases.

After Hours

We usually meet somewhere for dinner, getting together with people we don't get to see nearly often enough. We've learned that, when you've got tens of thousands of visitors in a city, it's a really good idea to make dinner reservations well in advance. We learned the hard way the year we had to wait several hours for a table at a popular restaurant: it wasn't bad because we walked around and visited and looked in shop windows while we waited, but we did nearly die of hunger. As with everything else about the big retreats, you just need to plan ahead.

At 7PM the vendors heave a huge sigh and close up their booths for the night; most drape netting or fabric around the entire booth, securing it with a couple of clips and leaving it all in the capable hands of the night security.

And with that, we call it a night and head back to our hotel to pack for the trip home. It's been a fabulous year of art retreats, indeed, but the season has ended. Now everyone will head back to their studios and workshops to prepare for the year ahead.

Conclusion

Did my year of art retreats change my life? Of course it did—it changed both our lives in lots of ways (you can bet I'm choosing a new hotel chain for our next trip). We met wonderful people, learned new stuff (soy wax resist! Painting!), saw amazing art, ate great food, stayed in fabulous places.

For me, though, the biggest change is this: I live in a town that doesn't have a lot of contemporary art, certainly not a lot of mixed-media art being displayed and shared and taught. Sometimes it seems as if there's no one for hundreds of miles who cares about the things I believe are vital: making art, keeping visual journals, taking workshops, learning new techniques. It can feel really isolating, as if I'm on an island where everyone else speaks another language. But having traveled across the country and met hundreds of people who love the things I love, I realize that in towns and on farms and in big cities every-

where, there are other people alone in their studios early in the morning and late into the night, making wondrous things, marvelous things, and being inspired by the very things that inspire me, too.

My year of art retreats showed me that I'm not alone, isolated in a part of the country that's not known as an art mecca, but am, instead, a part of a huge, interconnected web of art and ideas and inspiration that's humming along all over the world. Sometimes it may still feel as if we're working in complete isolation, but once we've gathered together and shared the experience of learning and creating, we never really feel the same again.

No matter what hour of the day or night you're in your studio, you can stop and realize that somewhere there's someone you've met making something magical in her tiny corner of the world. It's a wonderful feeling, indeed.

Featured Retreats

Adorn Me!
www.artunraveled.com
Linda Young: info@artunraveled.com

Art & Soul Hampton
www.artandsoulretreat.com
Glenny Densem-Moir: glennymoir@comcast.net

Art & Soul Las Vegas
www.artandsoulretreat.com
Glenny Densem-Moir: glennymoir@comcast.net

Art Unraveled
www.artunraveled.com
Linda Young: info@artunraveled.com

Artfest
www.teeshaslandofodd.com/artfest
Teesha Moore: artgirl777@aol.com

Artful Texas
(previously known as Shady Ladies)
www.artfultexas.blogspot.com
Jeri Aaron: jerilynski@aol.com

Bead&Button
www.beadandbuttonshow.com
Marlene Vail: Mvail@kalmbach.com

International Quilt Festival in Houston
www.quilts.com
Rhianna White: pubs2@quilts.com

Valley Ridge Art Studio
www.valleyridgeartstudio.com
Katherine Engen Malkasian:
kathy@valleyridgeartstudio.com

Art And Soul Retreats
Hampton Virginia 2010

Hi. It is a great pleasure to meet you and share class time with you! My trades are mono prints that can be used as journal pages or tip ins for altered books. Why not send them as a postcard to a friend, after you add your own creative additions of course. This is my first attempt at mono printing and it is addictive. I learned this technique while participating in one of Michelle Ward's GPP Street Team Crusades. I have no affiliation, just wanted to share where I learned the technique. Enclosed you will also find photo corners are made out of 100 acid-free paper product made from water hyacinth fibers. The water hyacinth weed clogs the inland waterways

The Average
Swallows

Quoted Contributors

MOTOR MOUTH

HIS HEAD'S LIKE A BUCKET, FULL OF METAL, WIRES & COMPUTER CHIPS, BUT HIS APPEARANCE ISN'T COMPLETE WITHOUT A SET OF WACKO LIPS!

3.

Index

Index (cont.)

About Ricë

Ricë Freeman-Zachery has written four previous books, including *Living the Creative Life* and *Creative Time and Space*. She writes artist profiles for a number of mixed-media publications, she blogs at voodoonotes.blogspot.com, and she interviews artists for podcasts at "Notes from the Voodoo Lounge" on iTunes. She is one of the editors at CreateMixedMedia.com, the online home for everything mixed media, and in those rare moments when she's not writing something or asking nosy questions so she can write something else, she's stitching and transforming all of her clothes into artwear. She lives in the middle of nowhere in Midland, Texas, with The Ever-Gorgeous Earl and a tribe of bossy cats.

About Earl

Earl Zachery's photographs have been published alongside his wife's writing in *Cat Fancy*, *RubberStampMadness*, and *Altered Couture*, where they created a column on transforming garments into art. After thirty-three years teaching health and English and coaching football, basketball, tennis, and track in the public schools in his hometown of Midland, Texas, Earl is more than happy to spend his days hanging out with artists and writers and people who don't whine about homework.

create mixed media

www.CreateMixedMedia.com

Join us at **CreateMixedMedia.com**,
the online community for mixed-media artists

techniques • projects • e-books • artist profiles • book reviews

For inspiration delivered to your inbox and artists' giveaways,
sign up for our FREE e-mail newsletter.

Discover more inspiration with these
other North Light titles by the Ricë.

Creative Time and Space

Discover secrets for keeping the creative
part of your brain engaged throughout the
day and pull yourself out of a creative rut
with ideas from an insider's look into the
studios of several successful artists.

Living the Creative Life

This in-depth guide to creativity is full of
ideas and insights from inspiring artists,
shedding light on what it takes to make
art that you want to share with the world
and simply live a creative life.